M000238407

IMAGES
of America

MENOMINEE INDIANS

ON THE COVER: For many Americans, their first experience of Menominee life is at a ceremonial powwow. It is therefore fitting that the readers' first glimpse of this book is of a man in mid-dance. (Courtesy College of Menominee Nation.)

IMAGES
of America

MENOMINEE
INDIANS

Gavin Schmitt

ARCADIA
PUBLISHING

Copyright © 2016 by Gavin Schmitt
ISBN 978-1-4671-1630-5

Published by Arcadia Publishing
Charleston, South Carolina

Printed in the United States of America

Library of Congress Control Number: 2015957313

For all general information, please contact Arcadia Publishing:
Telephone 843-853-2070
Fax 843-853-0044
E-mail sales@arcadiapublishing.com
For customer service and orders:
Toll-Free 1-888-313-2665

Visit us on the Internet at www.arcadiapublishing.com

For Lindsay Mae, in hope that she grows to love her roots

CONTENTS

ACKNOWLEDGMENTS

Thank you, to anyone who has ever purchased or read one of my books. Because of you, the publishers allow me to keep making them. And thank you, Arcadia Publishing, for continuing to allow me to tell Wisconsin's history to new audiences.

Thank you, to those on the reservation who helped in their own ways. This includes tribal administrator Jonathan Wilber and Rhonda Tucker at the cultural museum. Worth singling out are Jess Buettner and Leslie O'Kimosh at the Verna Fowler Library, who were invaluable. Unless otherwise noted, all images come from the library's archives.

Thank you, to Kate Hermsen, the image magician. In cases where my knowledge of scanning and other technical matters is lacking, Kate was there to make the necessary adjustments.

And as always, no thanks go to my best friend Chelsea "Dagger" Zareczny, who did absolutely nothing for this book.

INTRODUCTION

For many people, Wisconsin history began in 1848 with statehood, but before the Germans, before the French explorers, the Menominees were here. In fact, the Menominees were always here. No history of Wisconsin would be complete without covering the contributions of this proud people.

From what is today Oshkosh, up through Door County and into the Upper Peninsula of Michigan, the Menominees made their homes and weathered the seasons for thousands of years. Although their territory has shrunk considerably, they have left their mark in the names of cities, rivers, lakes, and other landmarks. Even as far south as Milwaukee, the Menomonee Valley and Menomonee Falls are seen. (The spellings vary, but the inspiration remains the same.)

Over the last hundred years, the fighting spirit of the Menominees has been tested again and again, and they have proved themselves resilient. Through struggles of sawmill ownership, poverty, the termination of tribal status, and other trials, the Menominees have found a way. They restored the reservation, expanded milling operations, built new towns (such as Middle Village), and found new sources of income, not the least of which was the casino.

The 21st century will bring still more challenges, as the tribe must now fight to keep its membership going. As more tribal members marry outside of the reservation, the next generation will find itself unable to be on the rolls. The legend of Spirit Rock says that the Menominees will exist as long as the sacred rock does. But the rock has eroded, and it may only be a matter of time before the tribe is forced out of existence through assimilation.

This book will hopefully appeal to a wide audience. First, it is for the tribe, so that its members can see and recall their traditions. Second, it is for those outside the tribe, whether they be historians or anthropologists. There is a great deal worth knowing about the Menominee people—both happy and sad, but all fascinating in its own way.

And then there is the group I hope appreciates the book the most: the folks, like myself, who trace their ancestry to the Menominees or have vague memories of the reservation but are removed from it. In researching this book, I was able to recover and bring out an important part of myself, and it is my hope that those with Menominee blood, no matter how little, are able to reconnect in some small way.

One

EARLY HISTORY

As with all American Indian tribes, it is nearly impossible to determine an exact beginning. The Menominees were in Wisconsin thousands of years before Columbus "discovered" America, and even thousands of years before Caesar ruled Rome. When Europe was in its infancy, the Native Americans had already established several territorial boundaries and settlements, governed by their own sets of laws and agreements.

The Menominees began to interact with European settlers more from 1660 to 1765, due largely to the St. Francis Xavier Mission of the Roman Catholic Church. Permanent churches were eventually built in 1877 and 1908 and remain central places of worship today. Most tribe members are Catholic, though they have incorporated traditional beliefs into their Christian faith.

As European influence spread, native lands grew smaller and smaller. Sometimes, this was achieved by treaty, and other times, through armed conflict. The Menominee lands were reduced from over 10 million acres to around 235,000 acres today. If there is one silver lining, however, it is that the Menominee Nation is one of the few Native American groups whose final home is on ancestral land rather than having been pushed farther west.

This chapter covers the time period prior to the 1900s. Obviously, due to the lack of cameras, photographs and other images will not cover the complete breadth or depth of the tribe's history. By necessity, it will be largely focused on the tribe's interaction with the Europeans and Americans.

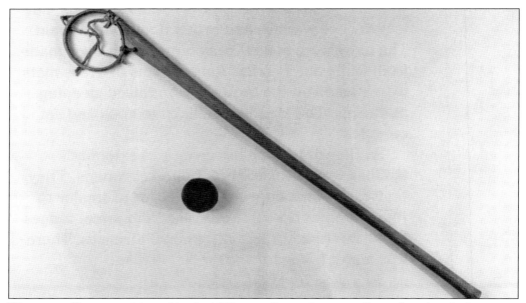

The game of lacrosse originated in the 1600s or earlier, and is generally attributed to the Iroquoian people in eastern North America. This photograph is evidence, however, that it was also played by the Menominees in the Midwest. (Courtesy Milwaukee Public Museum.)

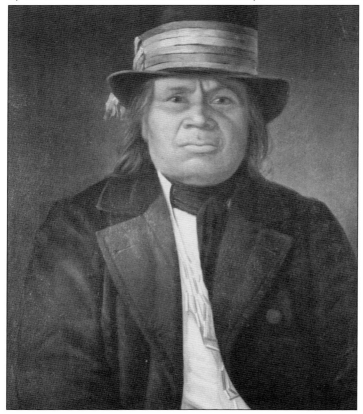

Thanks to his stubbornness, Chief Oshkosh helped the Menominees obtain a permanent reservation in their Wisconsin homeland. Unfortunately, he died young (in 1858) and was not able to see his people through the early reservation years. (Courtesy Wisconsin Historical Society.)

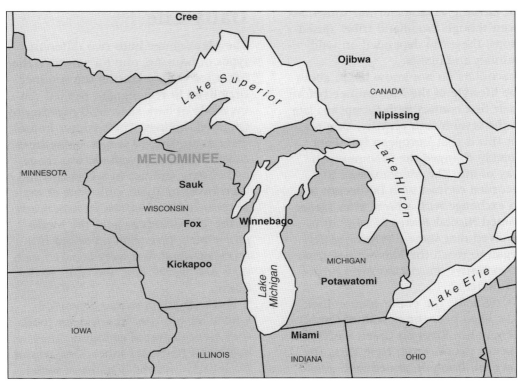

Cree

Ojibwa

Lake Superior

CANADA

Nipissing

MENOMINEE

Lake Huron

MINNESOTA

Sauk

WISCONSIN

Fox

Winnebago

MICHIGAN

Kickapoo

Lake Michigan

Potawatomi

MICHIGAN

Lake Erie

IOWA

Miami

ILLINOIS

INDIANA

OHIO

Like most native tribes, the Menominees lost or sold the bulk of their land to the Europeans. They are fortunate, however, in that they are one of the few tribes whose modern-day territory coincides with their ancestral lands.

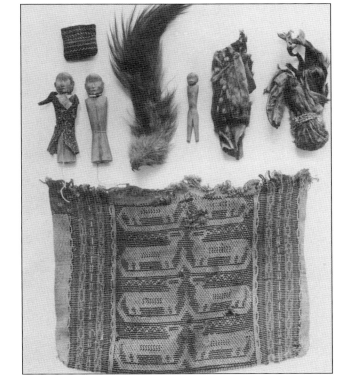

Pictured here is a Menominee hunting bundle. Hunters used these objects during rituals to ask the gods to protect and assist them during the hunt. (Courtesy American Museum of Natural History.)

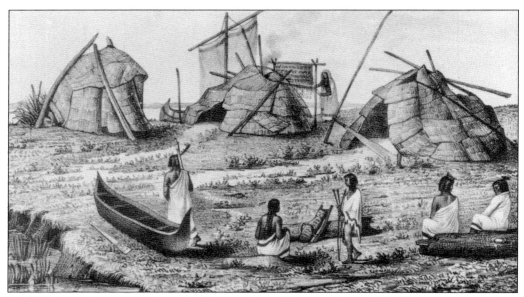

In this image is an engraving of a Menominee village made in 1838. The wigwams shown here were made of frames of bent saplings covered with mats of cedar or birch bark. (Courtesy Newberry Library.)

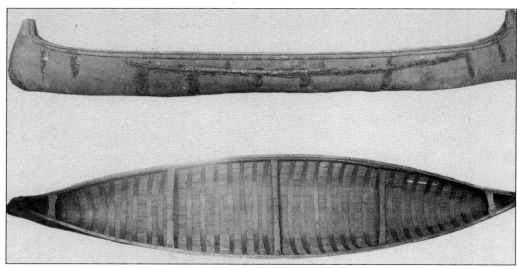

A Menominee canoe, covered in birch bark, is seen here. The French fur traders admired the way the Menominees could use such small boats on the stormy waters of the Great Lakes. (Courtesy American Museum of Natural History.)

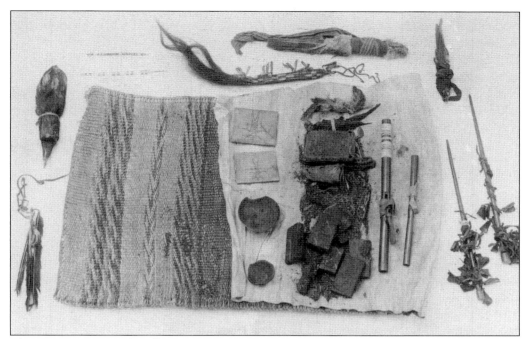

This Menominee war bundle contains objects and talismans said to hold magical powers. Combined with various songs and rituals, the talismans could promote victory in war. (Courtesy American Museum of Natural History.)

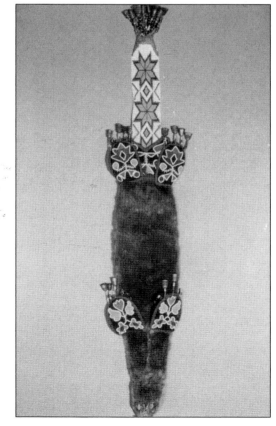

Seen here is a Menominee medicine bag fashioned out of beaver skin. Beaver was of great value to the Europeans—especially the French—and the Menominees would use such pelts to trade for European goods. (Courtesy Milwaukee Public Museum.)

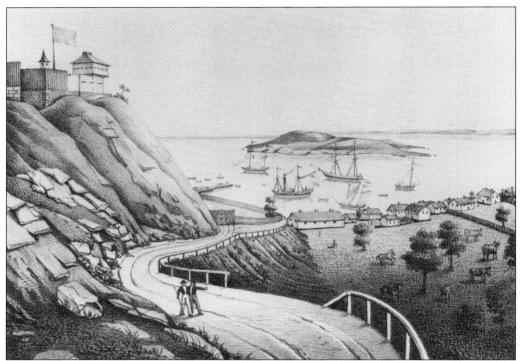

Fort Michilimackinac, located on Mackinac Island, is situated at the strategic point where Lakes Huron, Michigan, and Superior meet. Starting in the 1670s, the Menominees often canoed the 140 miles from Green Bay to the fort in order to conduct trade. (Courtesy Newberry Library.)

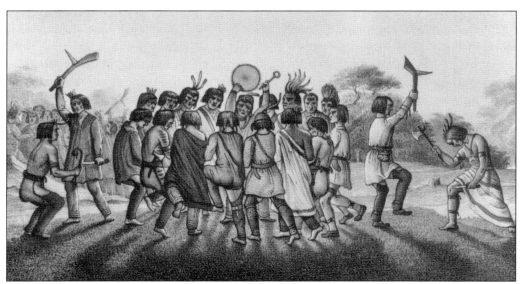

A war dance is performed by the Menominees at Green Bay. Fr. Louis Andre lived with the tribe from 1671 to 1684 and baptized many of them Catholic but could not get the tribe to give up their traditional dances. (Courtesy Newberry Library.)

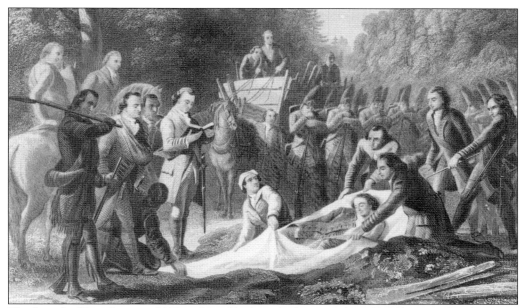

The burial of British general Edward Braddock took place in July 1755, following a battle at Fort Duquesne. With the help of the Menominees, the French defended their fort and killed 1,200 of Braddock's 2,000 soldiers. (Courtesy Library of Congress.)

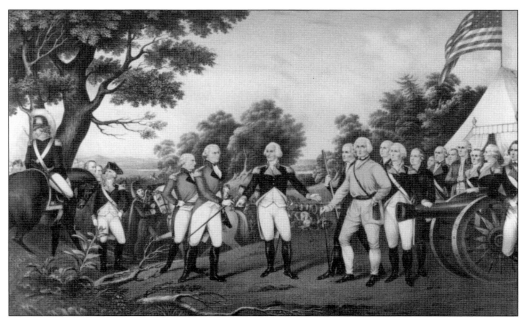

British general John Burgoyne surrenders his sword to the Americans at Saratoga, New York, in October 1777. Burgoyne blamed his defeat on Menominee warriors under his command who abandoned him to return home for the fall hunt. (Courtesy New-York Historical Society.)

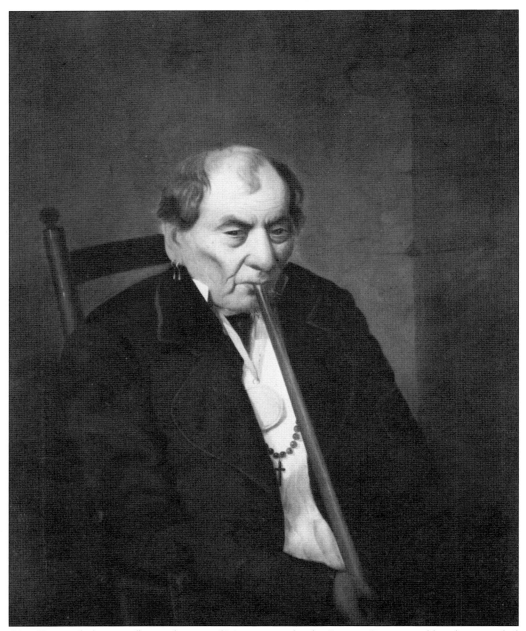

Chief Iometah (pictured) was the son of Menominee leader Josette Carron and brother to tribal spokesman Tomah. Iometah fought on the side of the British during the War of 1812. This painting was done by Samuel Marsden Brookes in the 1850s, when Iometah was around 80 years old. (Courtesy Wisconsin Historical Society.)

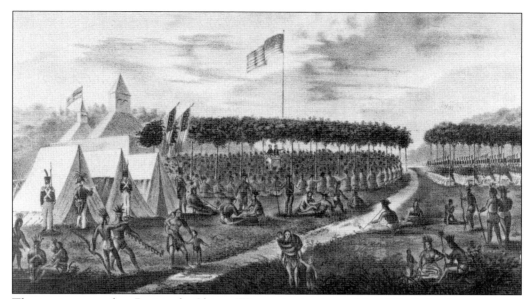

The treaty council at Prairie du Chien, Wisconsin, is pictured in 1825. Federal government representatives met with Menominee leaders in order to define the boundaries of tribal land. (Courtesy Library of Congress.)

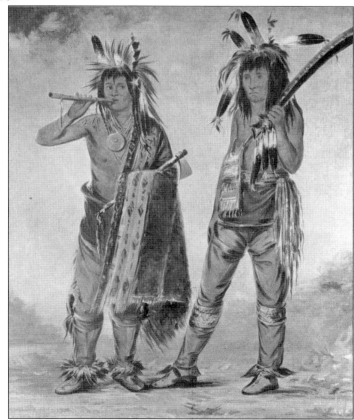

Traveling artist George Catlin (1796–1872) visited the Menominees in 1832 and painted these two youths. Catlin, a native of Pennsylvania, was the first white man to portray Plains Indians in their native territory. (Courtesy Museum of American Art.)

Menominee chief Reginald Oshkosh was honored to attend the inauguration of Pres. Woodrow Wilson in 1913. On the trip, he also stopped at the Bronx Zoo and American Museum of Natural History. (Courtesy Wisconsin Historical Society.)

TREATY OF THE CEDARS

The Treaty of the Cedars was concluded on the Fox River near here September 3, 1836. Under the treaty the Menominee Indian nation ceded to the United States about 4,000,000 acres of land for $700,000 (about 17 cents per acre). The area now contains the cities of Marinette, Oconto, Appleton, Neenah, Menasha, Oshkosh, Wausau, Wisconsin Rapids, Stevens Point and many others. The six-day meeting ended in a spirit of mutual respect and fairness. Governor Dodge said, "I view it as a matter of first importance to do the Indians ample justice in all our treaty stipulations," and Menominee Chief Oshkosh later affirmed, "We always thought much of Governor Dodge as an honest man." The treaty was proclaimed February 15, 1837, and the Indians began moving to their new homes west of the Wolf River.

Erected 1958

The Treaty of the Cedars was negotiated in 1836–1837 by Chief Oshkosh and Gov. Henry Dodge near what is today Little Chute. The Menominees sold four million acres of land for $700,000; the land extended north to Marinette, west to Stevens Point, and south to Oshkosh.

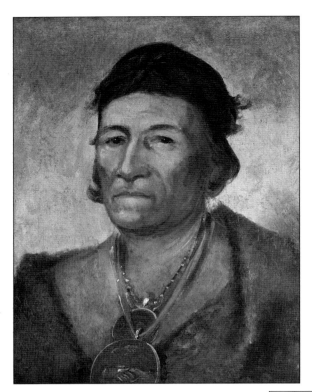

Chief Big Wave, also known as Komaniken or "the philosopher," was a prominent member of the tribe. Making his home near Lake Poygan before relocation three miles north of Keshena, he was involved with and signed most of the pre-reservation treaties.

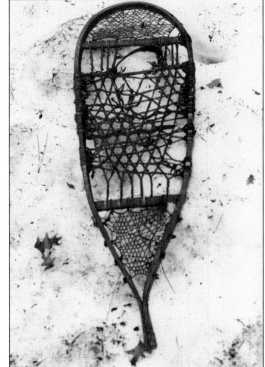

Prior to the 20th century, Indian peoples had the most advanced snowshoes in the world. Each tribe had its own unique shape and size, with all tribes in snowy regions having some variation. Shown here is the Menominee variation.

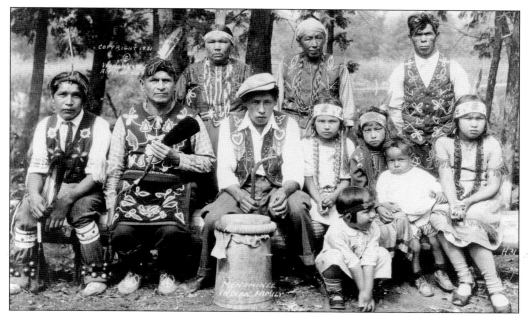

Some Menominees are pictured at Antigo in 1931. Antigo, located just northwest of the reservation, was a booming area from the 1930s to the 1950s thanks to the railroad. This image demonstrates how the Menominees straddled the traditional and modern worlds, even in clothing. While they adapted to European shirts and shoes, they continued to add their intricate beadwork to make the style their own.

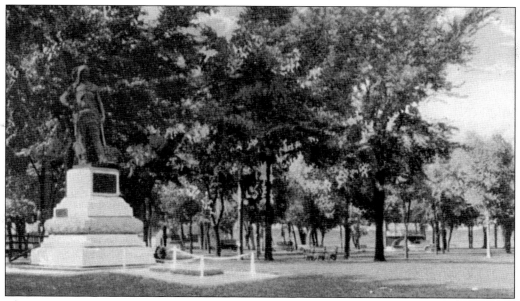

This postcard shows Menominee Park in Oshkosh. The statue is of Chief Oshkosh, and at the base of the statue is the final resting place of Oshkosh himself. He is one of the few historical leaders to have his grave on public display.

This is an image of Chief Oshkosh of the Menominee, pictured approximately in the 1930s. Following the fame and success of the original Chief Oshkosh, his family took on the name as a surname, with descendants Reginald and Roy having the title of chief.

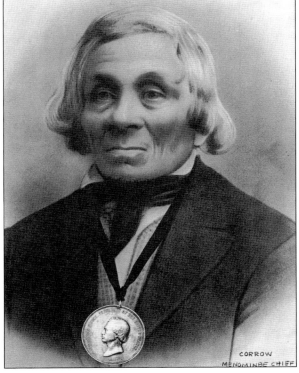

Chief Carrow is shown with a Franklin Pierce Friendship, or Indian Peace, Medal. Indian Peace medals were established around 1792 and became prominent during the Lewis and Clark Expedition. The front showed the current president, and the reverse featured clasped hands to signify peace.

Seen here is Markomete, a Menominee brave, as portrayed by Charles Bird King (1785–1862). The portrait was commissioned by Thomas McKenney, superintendent of Indian Affairs in the 1820s. Markomete means "bear oil," which was considered a delicacy.

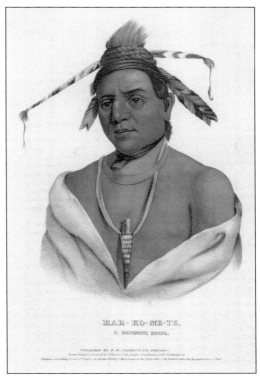

MAR - KO - ME - TE,
A MENOMINE BRAVE.

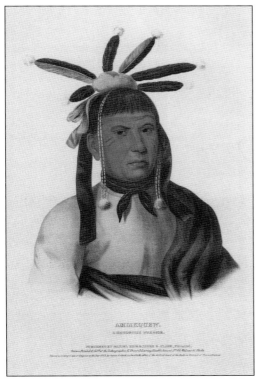

This image is of Amiskquew, another Menominee, as depicted by Charles King. His portraits started off as charcoal sketches and were later redone as paintings. The charcoal originals still exist.

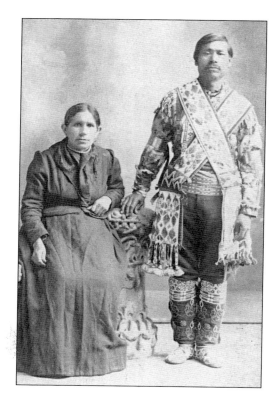

Menominee tribal member Henry Wolf is shown here with his "Winnebago wife." Intertribal relations in modern times have been peaceful, and it is not uncommon for the Menominees to marry members of the Winnebago (commonly known as Ho-Chunk) or Oneida Nations.

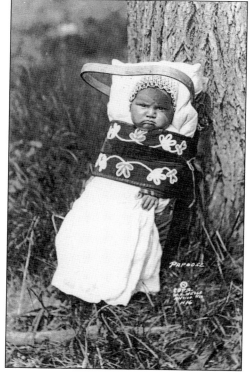

The word *papoose* properly refers to a child, and the carrier is called a cradleboard. This convenient way to carry a child was so popular throughout the Americas that many tribes still use them today.

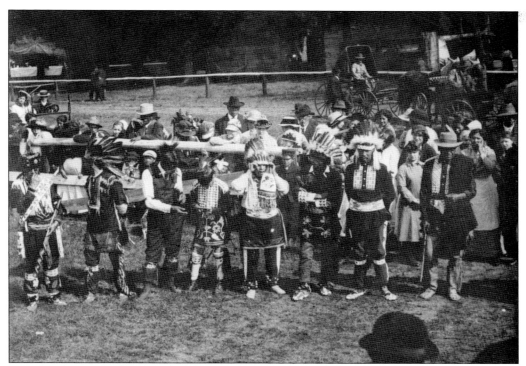

Here are the county fairgrounds in 1914. Other than the horse and buggy, not much has changed in the past hundred years; the county fair is still a great opportunity for outsiders to witness an Indian powwow.

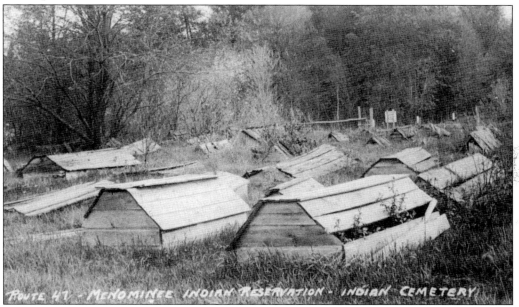

The phrase "dust to dust" may holds more symbolism for the Menominees than for their white neighbors. The Menominees recognize the earth not only as a beginning and end, but as an essential part of daily life, providing food and shelter.

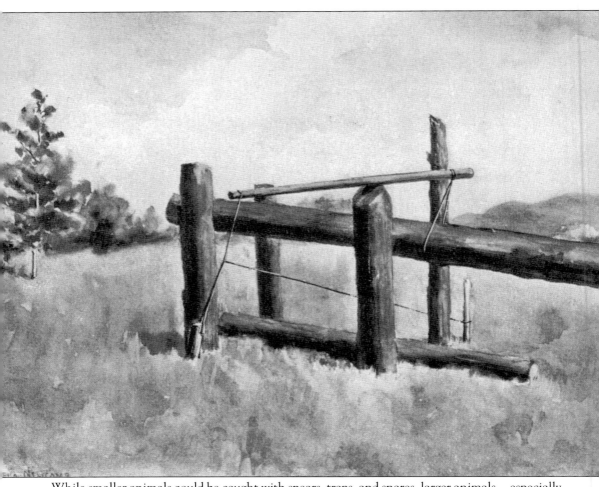

While smaller animals could be caught with spears, traps, and snares, larger animals—especially bears—could be brought down with a deadfall, like the one shown here. This painting was created by Josepha Newcomb Whitney.

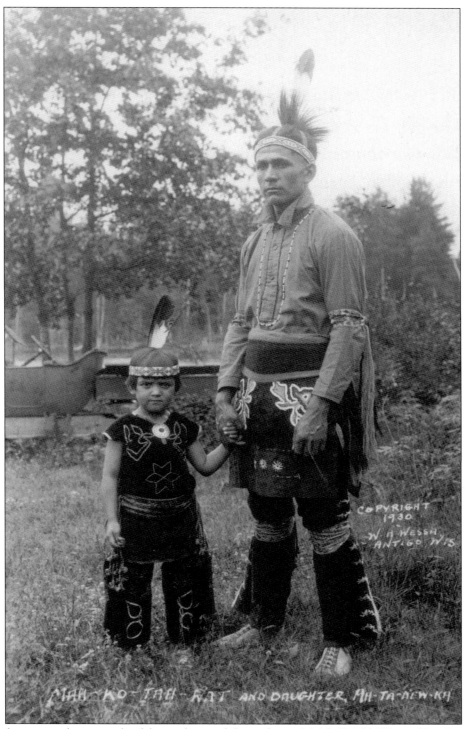

Seen here is another example of the modern and the traditional. Mah-Ko-Tah-Wat and his daughter
Ah-Ta-New-Ka adorn their modern clothes with traditional beads, jewelry, and feathers.

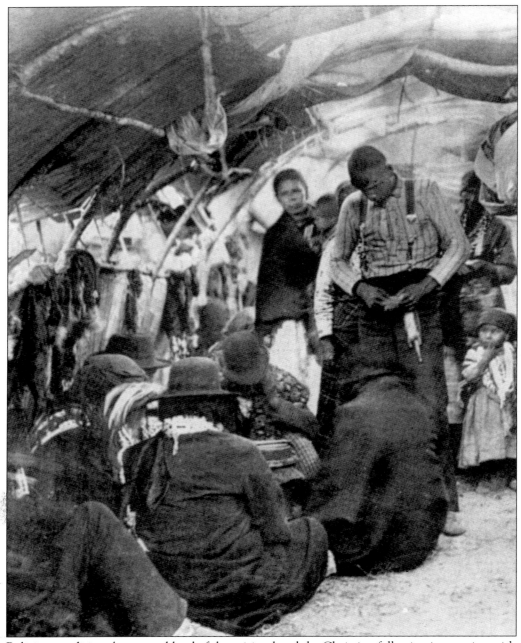

Religious traditions became a blend of the spiritual and the Christian following interaction with Europeans. The people shown here are gathering in the Medicine Lodge while also upholding the Roman Catholic faith.

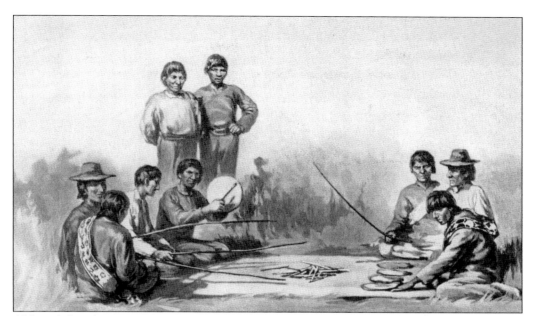

Although best known for playing lacrosse, the Menominees had developed a wide variety of games involving skill and chance. Sticks were used to keep score. Shown here is one such game.

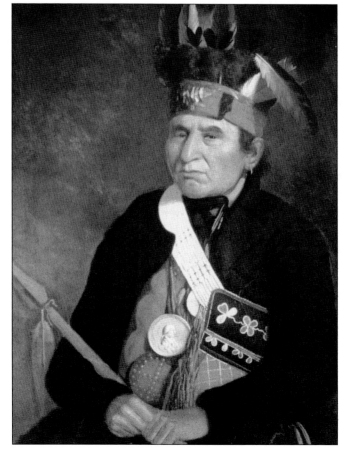

Chief Souligny (1783–1867) was the grandson of a French trader and sided with the British during the War of 1812. He then made peace with the Americans and fought with them in the Black Hawk War of 1832.

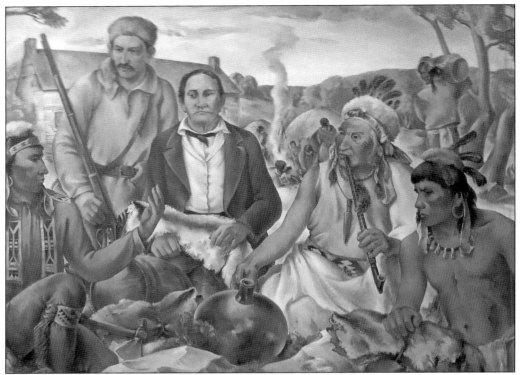

In 1938, as part of the Works Progress Administration, Bulgarian painter Walter Rousseff created this image of Augustin Grignon trading with the Menominees around 1800. The painting hangs in the Kaukauna Post Office. (Courtesy Kaukauna Post Office.)

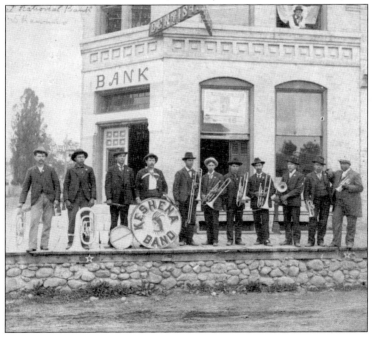

Seen here is the Menominee Indian Band of 1890. Although these men are unidentified, the original band was formed in 1885 by Rev. Father Oderick. The original members were Peter Lookaround, Simon Dodge, Frank Gauthier, John Gauthier, Louis Gauthier, John Fox, James Grignon, Jerome Grignon, Jerome Lookaround, Jerome Lawe, Charles Frechette, and Thomas Shanowat. Likely, at least some of those men are pictured here. (Courtesy Shawano Public Library.)

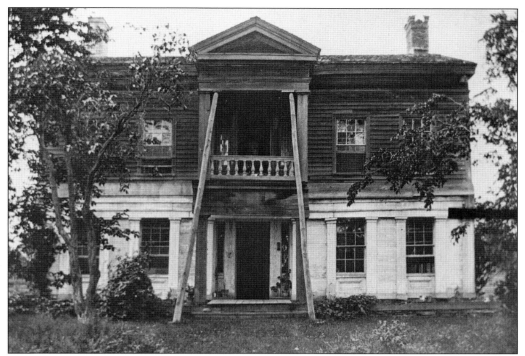

The Charles Grignon residence in Kaukauna, sometimes called the "Mansion in the Woods," served as a post for trade between the French and Menominee. Grignon himself was part Menominee and could serve as translator for his associates.

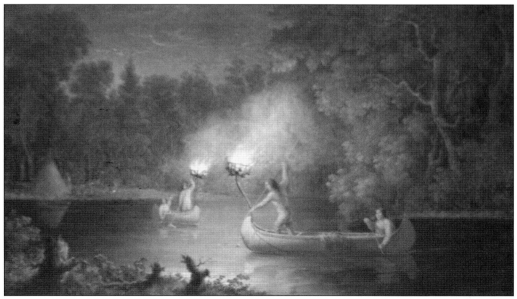

Although Irish Canadian painter Paul Kane (1810–1871) was best known for his images of Canadian First Peoples, he was also responsible for this striking image of the Menominees spearing fish.

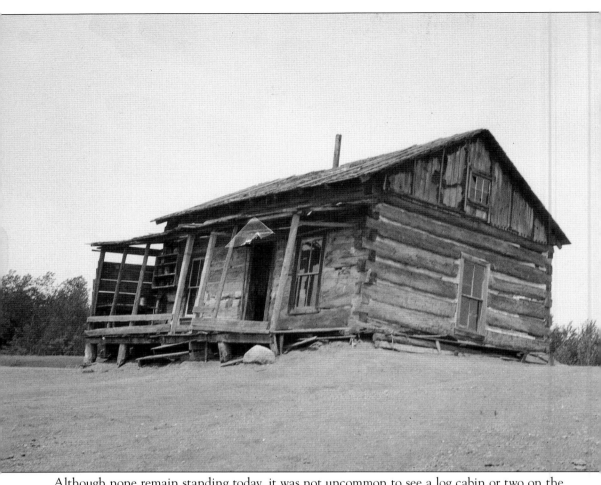

Although none remain standing today, it was not uncommon to see a log cabin or two on the reservation as the Menominees transitioned from traditional to modern housing. The influence of this European architecture was most common in the upper Midwest.

Two

KESHENA

The city of Keshena is the largest on the reservation. It also serves as the seat of government for both the county and the tribe (which are—in many ways, though not completely—synonymous).

The name comes from a Menominee chief and roughly translates to "swift flying." The legend goes that Chief Josette had a vision of hawks, the representatives of the thunder phratry (brotherhood), and named his son in their honor. While still a minor, Oshkosh acted on Keshena's behalf as chief, but Keshena came into his own by 1850. In May 1854, Keshena was one of the signers of the treaty creating the Menominee reservation, along with Oshkosh and several other leaders. One of his most memorable acts was granting land to the Munsee-Stockbridge people, who had been forced out of New York, in February 1856.

Chief Keshena gave his name to the city after settling there in 1852. Joining him were leaders of the various bands—Aia-miqta, Carron, Lamotte, Akinebue, Oshkiqhinanui, and Watasau— as well as all their followers. Keshena (the city) became the first permanent settlement on the reservation.

Notable residents of Keshena have included boxer Marcus Oliveira, actress Sheila Tousey, and assemblyman David V. Jennings.

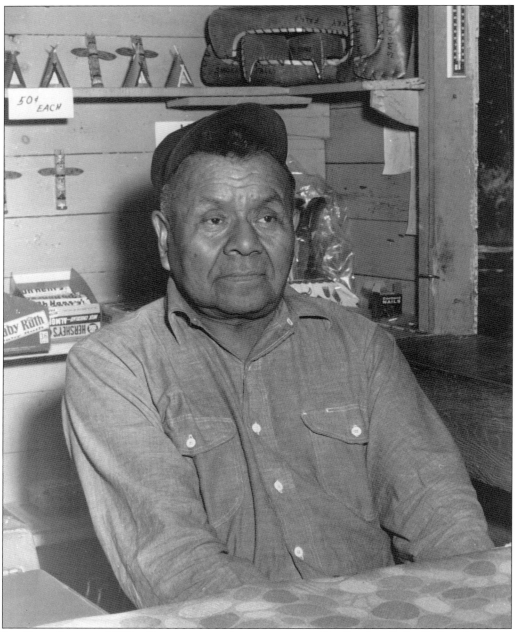

Joe Corn (born in 1870) sells souvenirs at his own store at Big Smokey Falls. Today, the site is well known for its whitewater rafting. By the time this photograph was taken, Corn had become one of the tribe's respected elders.

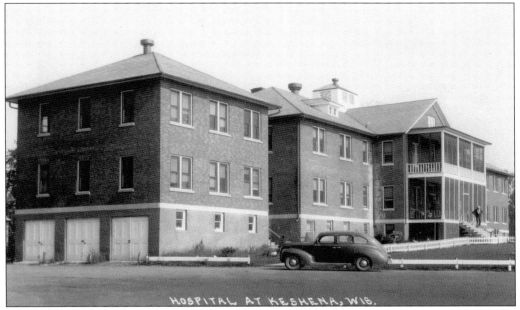

Shown here is the Keshena Hospital, the earliest medical facility on the reservation. Today, the tribe has the Menominee Clinic, which can proudly boast of being the first Indian-owned health facility when it opened in 1977.

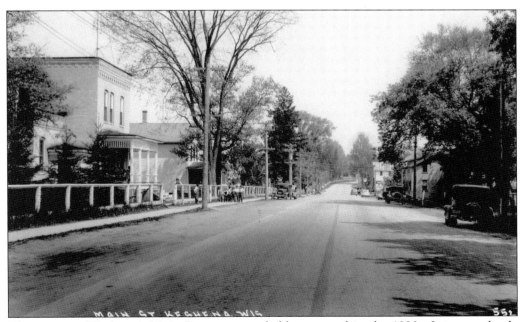

This image of Keshena's Main Street was probably captured in the 1920s. It is completely unrecognizable today, except perhaps for a tree or two. Not only have the cars changed, but none of the buildings shown remain standing.

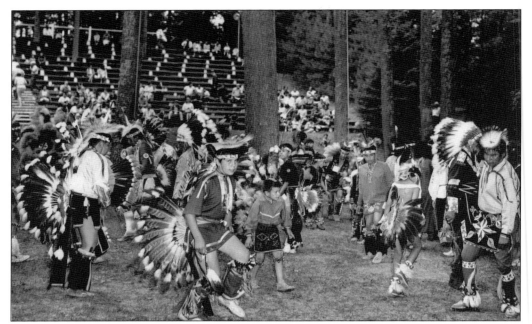

Some dancers are seen here during a practice run of the Menominee Indian Fair in Keshena. When show time comes, those bleachers in the background will be packed with popcorn-munching spectators.

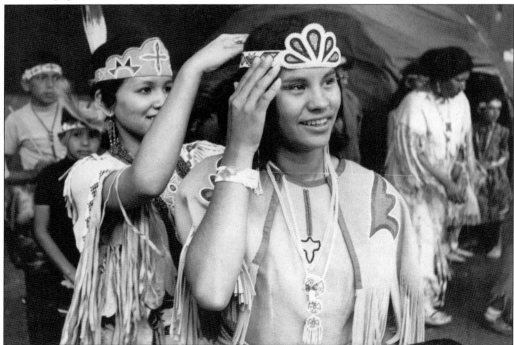

Karen Washinawatok is crowned Miss Menominee. Washinawatok went on to be the director of the Menominee Language Program, a chairwoman of the Menominee Language and Culture Commission, and a Menominee tribal chairwoman.

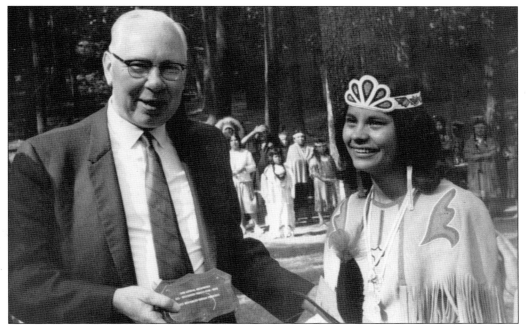

State senator Gordon August Bubolz (1905–1990) and Karen Wescott-Washinawatok, the newly crowned Miss Menominee, are pictured here. Bubolz was a champion of conservation, and a nature preserve bearing his name is located near Appleton, Wisconsin.

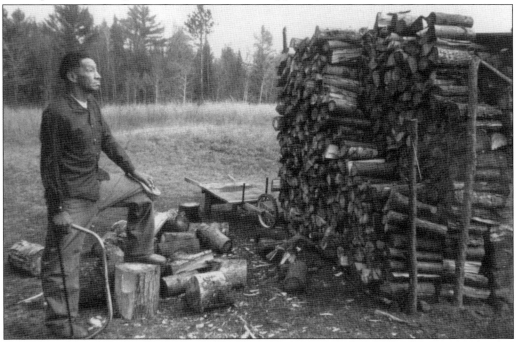

Barney Dowd (1913–1993) was a proud hunter and enjoyed walking the Northwoods around Hazelhurst with his friend Harvey Sunn. In his earlier days, he worked road construction and married the former Jane W. Amob (1907–2002) in Shawano in 1959.

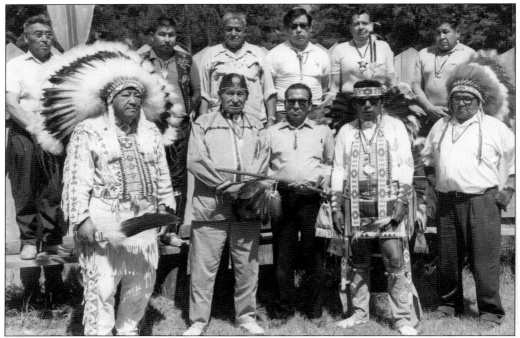

Chief Sam Frog, front row, far left; Johnson Awonohopay (1913–1988), front row, third from left; Wayne Martin, and others are pictured in Keshena. Awonohopay was one of the last tribal members to be familiar with Big Drum rituals, and even he had to be refreshed on occasion by the Ojibwa people. Today, the traditions are almost extinct.

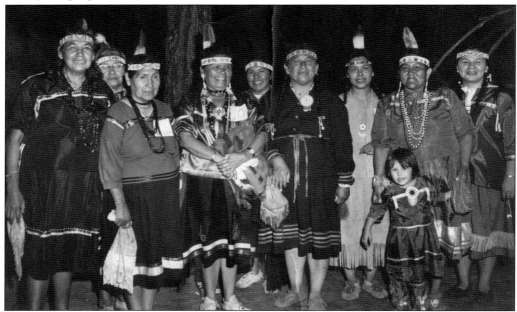

Seen here is a group of Menominee women, made up of Marion Wynos, Helen Wynos, Mary Dowd, Shirley Daly, Delvinia Okimosh, Roseanne Wynos, and Philmine Sheshkiquin. Notice that their outfits are not as elaborate as their male counterparts.

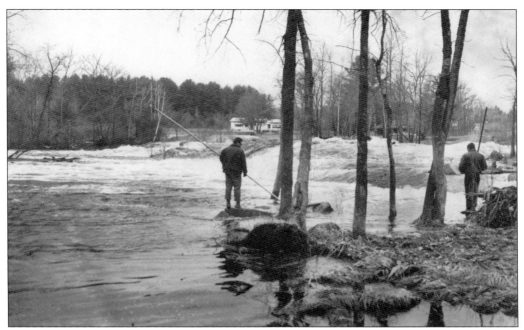

Robert Perez (born 1939) spears pike at Keshena Falls. His father, Camilo, was born in 1939 in Mexico and settled on the reservation, taking up working at the sawmill and marrying a tribal woman, Mary Kinepoway.

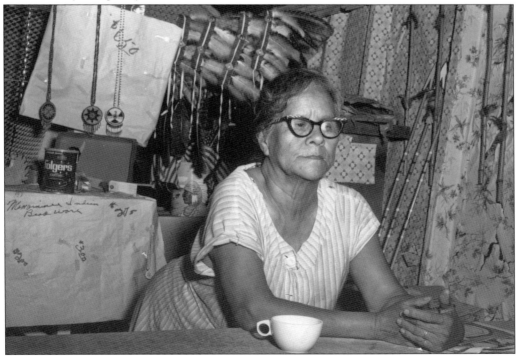

Theresa Deer Wescott (1907–1991) is shown here at Big Smokey Falls. Wescott, under her tribal name Peh-Teh-Woh-Cee-Sac-Coc-Woc, was a teacher of the Menominee language.

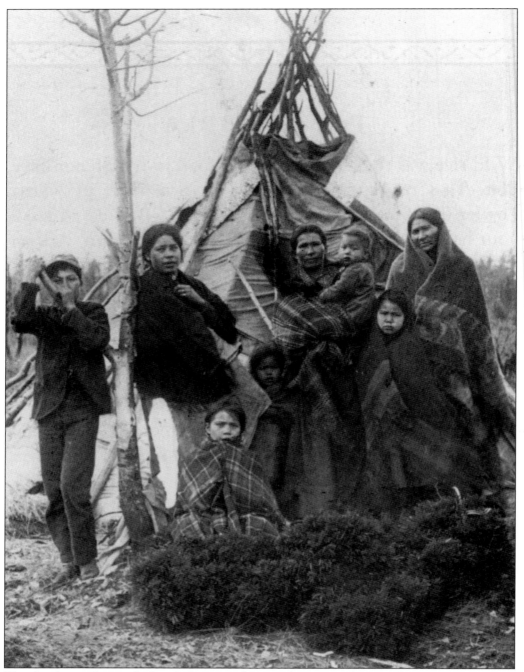

This family stands outside their lodge around 1900. There is a sadness to the photograph, as the poverty present is overwhelming. How this family survived Wisconsin's winters is not known. (Courtesy the Hulton Archive.)

The medicine lodge shown here may imply the wrong thing. Most medicine lodges were not actual places for medical treatment but more accurately sweat lodges, which would bring on visions. They are similar in structure and mechanics to the Finnish sauna. (Author's collection.)

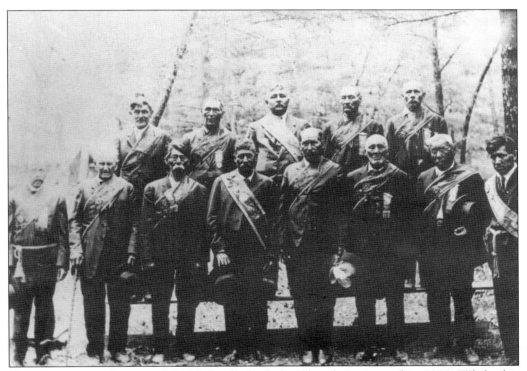

The Temperance Society of St. Michael's Catholic Church is pictured in 1908. While this group explicitly rallied against drinking alcohol, various other groups came into being when education and health care grew increasingly important for the Menominees. (Courtesy Menominee Tribal Archives.)

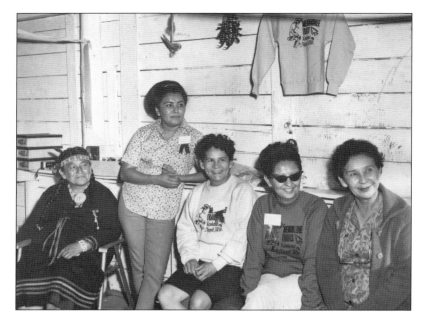

Seen here are, from left to right, Delvinia Okimosh, Davey Jean Okimosh, Betty Jean Gray-Shawano, Barbara Frechette, and Jennie Weso at Smokey Falls. The women worked the tourism angle, as shown by the Menominee Trails sweatshirts.

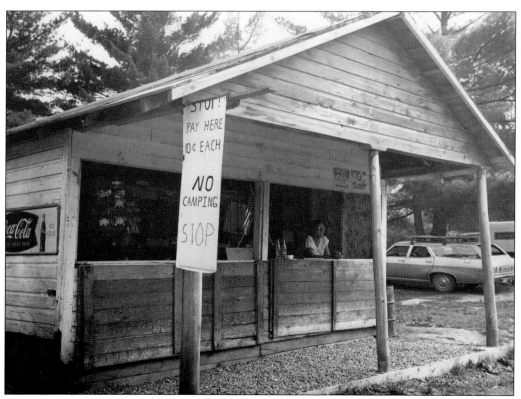

The Big Smokey Falls trading post is pictured from the outside, with Theresa Wescott running the concessions. Access to the falls is being offered at a price that cannot be beat: only 10¢.

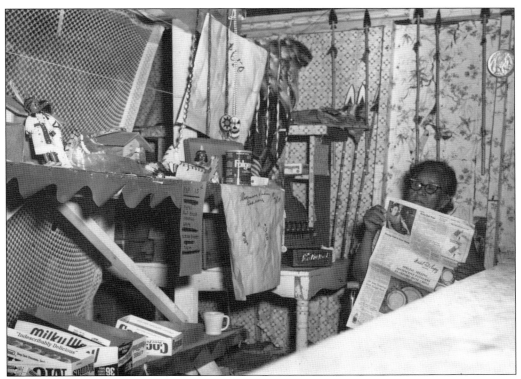

This image was captured inside the Big Smokey Falls trading post, again with Theresa Wescott. One could purchase a Milky Way for the kids or a refreshing pop for a mere 15¢. Anyone who was ever a Scout knows the joy of a trading post purchase.

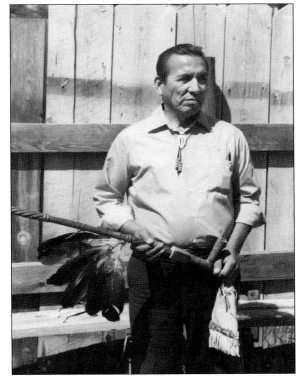

Johnson Awonohopay (1913–1988), a lumber mill employee by day, was also the local leader of the Big Drum religion. His sons were chosen as his successors, but they never learned to speak Menominee fluently.

Monroe "Moon" Weso (1904–1983) lived on the north side of Neopit and was employed in the lumber mill. He was an influential member of the Turtle Clan and lived in a home that was the former jail.

Wallace Pyawasit (1919–1981) was a nationally known tribal leader. As a medicine man, he treated his fellow tribesmen and then would fly on the "iron-tailed hawk" to gives speeches around the country.

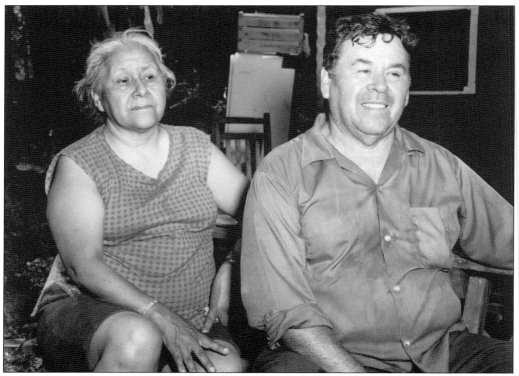

Merceline (1914–1984) and Jerome Sanapaw (1914–1979) appear multiple times in this book, as they should. Probably no other couple in Menominee history was so important in their quest to keep traditions alive and teach them to schoolchildren throughout the area.

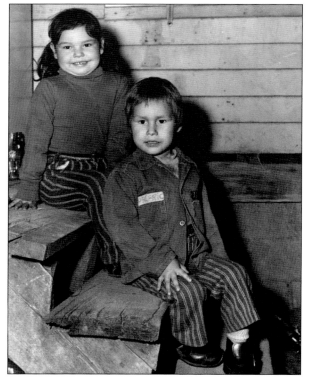

Seen here in the 1970s, Diana and Kenneth Sanapaw may well be the next generation to pick up the reins from the Sanapaws. It is far too early to start writing their history.

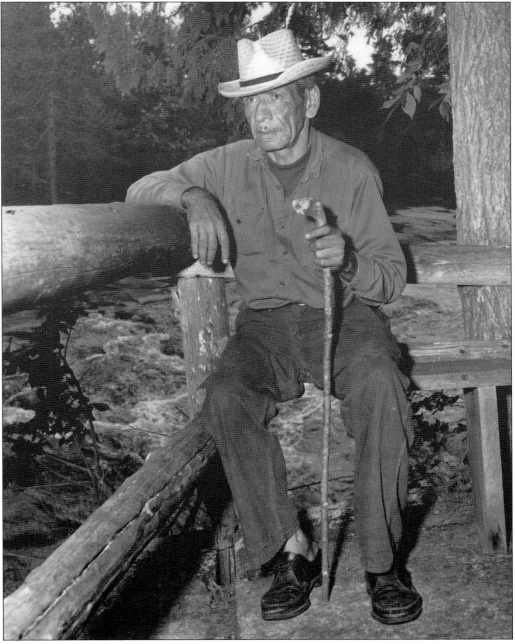

Chief Warrington was a member of one of the largest families on the reservation. A patriarch to many, later in life, he enjoyed relaxing when he could and snacking on Cracker Jack.

Fred A. Schmidt lived in Appleton and worked for the *Post-Crescent*. In the 1960s, he created a series of oil paintings featuring Menominee people. Many are on display today at the Hortonville Public Library.

St. Michael's Catholic Church is the primary church on the reservation. The Catholic religion has been an important part of Menominee culture going back over 300 years and remains the most-practiced faith of the tribe.

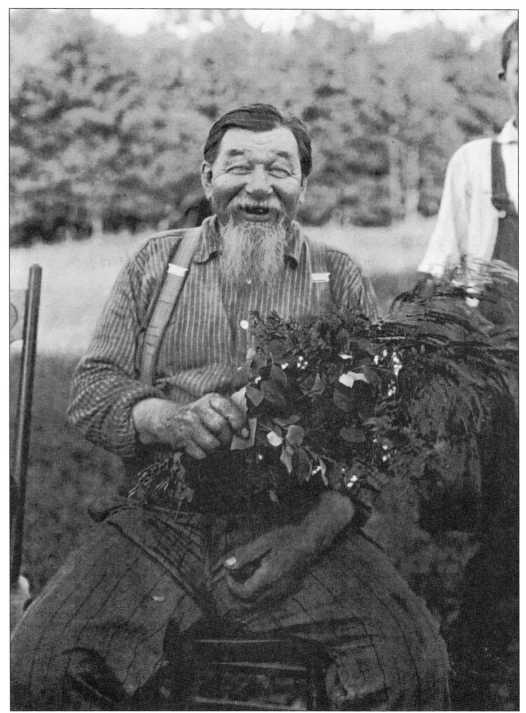

Capt. John Valentine Satterlee (1852–1940) was raised by a white father and Menominee mother and received education in both worlds. As a child, he went through the traditional fasting periods in order to bring on visions. He later acted as an interpreter for anthropologists.

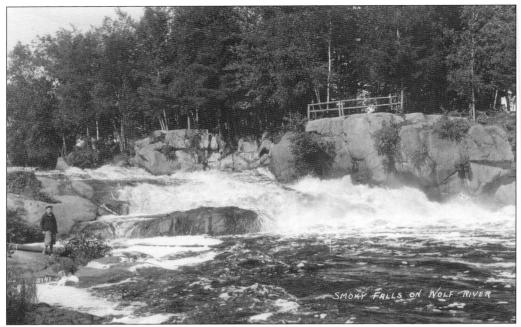

People can really get a sense for just how big the Big Smoky Falls are when they see this boy standing beside them. Only the bravest of adventurers are going to go down the Wolf River in an inner tube.

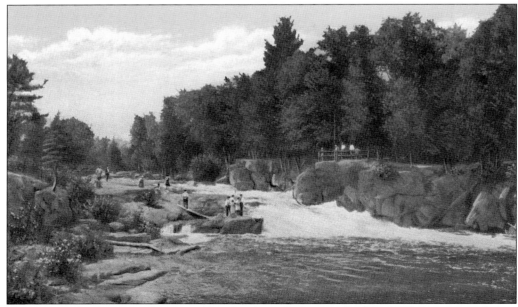

This postcard offers a similar view of Big Smoky Falls (notice the fence). These tourists do not need a raft to enjoy the beauty and majesty of the rushing water. Hopefully, no one will fall in.

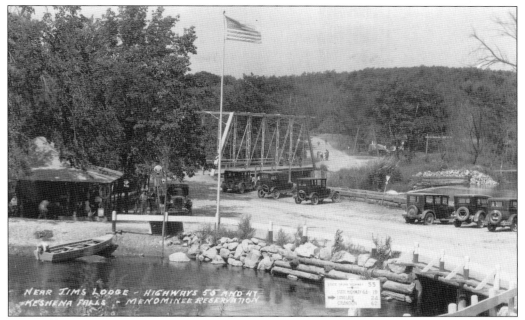

Pictured here is Keshena Falls, located near Jim's Lodge, just off of Highway 55. The lodge offered "Indian novelties" as well as staple items like gasoline.

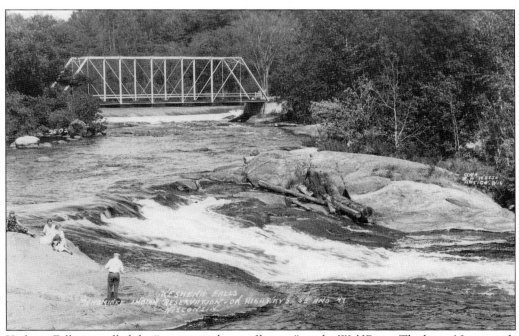

Keshena Falls was called the "most visited spot of beauty" on the Wolf River. The brave Negomeosh "shoots the falls" every Sunday for tourists, and both Chief Oshkosh and "Sunny Jim" have curio shops here.

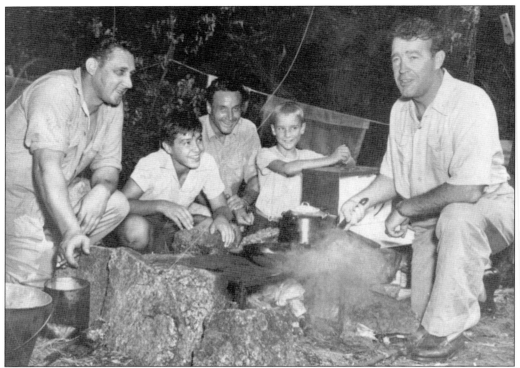

Special guests of the Menominees are seen here around 1947; from left to right are Notre Dame football assistant coach Edward "Moose" Krause (1913–1992), Fred Miller Jr., Frederick C. Miller, Frank Leahy Jr., and Notre Dame football coach Frank Leahy (1908–1973). (Courtesy Shawano Public Library.)

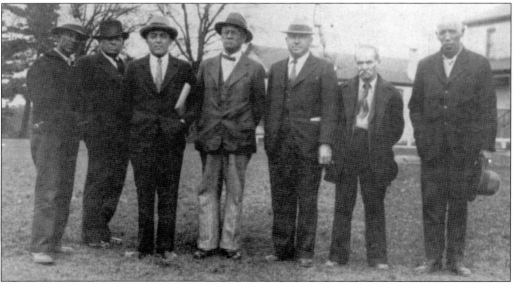

Seen here is one of the first Menominee Indian Advisory Councils, made up of, from left to right, Peter White, Simon Beauprey, Roy Oshkosh, Frank Gauthier, Charles Frechette, Mose Tucker, and Peter Pamonicutt. (Courtesy Shawano Public Library.)

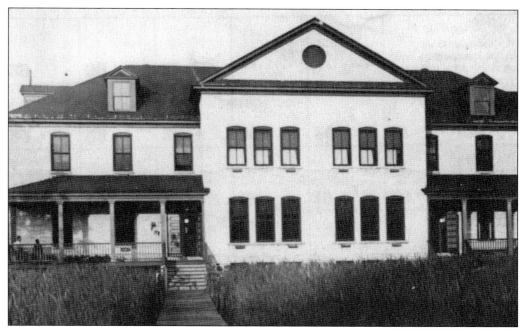

The Government School in Keshena is pictured around 1900. Located near the Keshena water tower, the building served as a boarding school up through the 1940s. (Courtesy Shawano Public Library.)

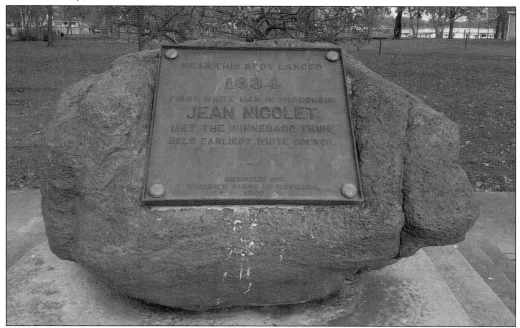

On the north end of Doty Island in Menasha is this dedication to Jean Nicolet, the first recorded white man in Wisconsin. When he landed on the island in 1634, he was met by Menominee and Ho-Chunk tribal members. One can imagine the communication difficulties that ensued. (Author's collection.)

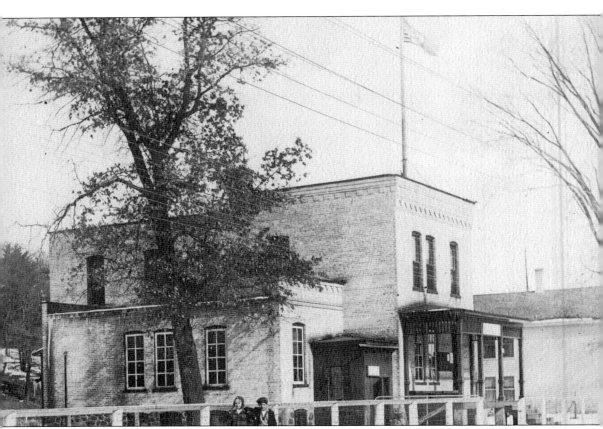

Pictured around 1932 is the Keshena Indian Agency office, where the federal government would interact with the tribe. During the 1960s, the building was used as a youth recreation center. (Courtesy Shawano Public Library.)

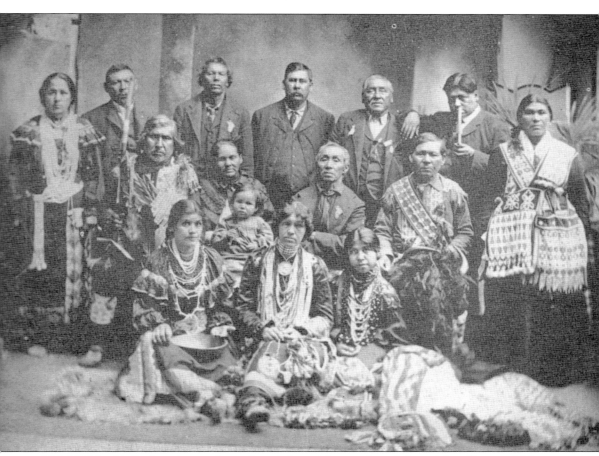

Chief Oshkosh's Retinue is seen here; from left to right are, from left to right, (first row) Mary Warrington, Theresa Beaupre LaMotte, and Agnes Corn; (second row) Thomas Hog, Mary Oshkosh with son Tom, Neopit Oshkosh, and Mose Corn; (third row) Adell Gauthier Neff, Peter LaMotte, Perotte, Joe Gauthier, Acquinnie Oshkosh, John Gauthier, and Louise Amour (aka Chemon). (Courtesy Shawano Public Library.)

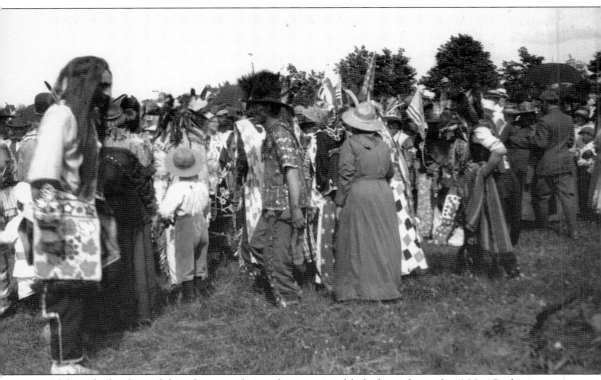

Although the date of this photograph is unknown, it is likely from the early 1900s. Gathering at the fair in Keshena, these members of the tribe are anxious to show off their traditional clothing and dances for the curious tourists.

Three

NEOPIT

Of the handful of cities on the reservation, Neopit is the second largest, and even it has fewer than 1,000 people living there. Like Keshena, the city is named for a prominent member of the tribe.

Neopit was born in 1831 to Chief Oshkosh and his wife, Bambani, making him a contemporary of Keshena. He was elected chief in 1875 after his brother Akwinemi stabbed a man in a drunken brawl and was deemed inappropriate for the leadership post. Neopit was a tribal judge and the head of the medicine society.

Chief Neopit remained a pagan his entire life, though he raised his 14 children in the Catholic faith. The children adopted the surname Oshkosh, with the most notable being Reginald Oshkosh, mentioned elsewhere in this book.

The distinguishing feature of Neopit is the lumber mill. No other single business on the reservation has employed so many people for so long. Now in operation for over 100 years, it offers the sort of job that has been passed from father to son for four generations.

Neopit's most famous resident is also its most infamous: Evelyn Frechette, known as "Billie," who was the girlfriend of Midwest gangster John Dillinger. This chapter pays special attention to her exploits.

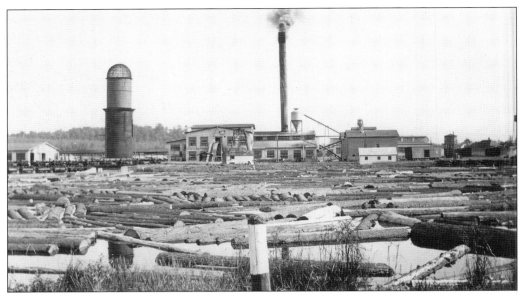

The Menominee Indian Mills at Neopit began railroad logging in about 1911. The railroad was later abandoned because the Indian Mills changed over to selective cutting of trees and found that the railroad was not flexible enough to use with this logging method. (Courtesy Menominee Public Library.)

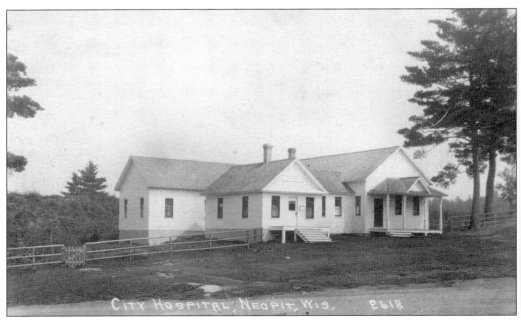

Though hard to imagine in a town so small, Neopit once had a city hospital. Although simple, it allowed some conveniences, such as mothers being able to give birth with assistance without traveling.

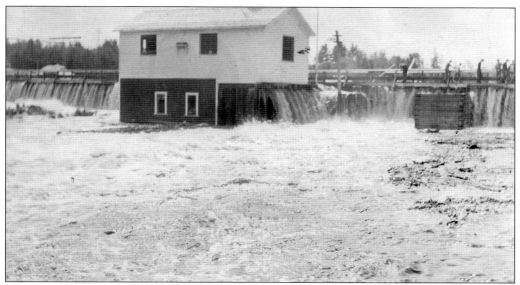

The Neopit millpond and dam served multiple purposes. The control of water allowed for logs to be easily floated in, and the dam also allowed for hydroelectric power, which was something revolutionary at the time.

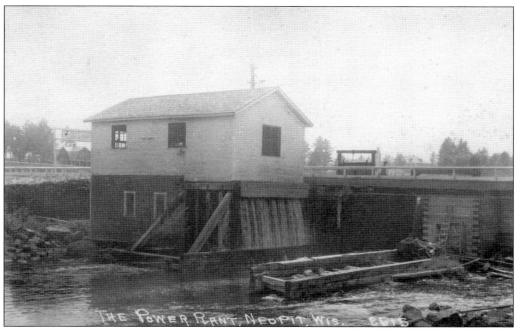

Pictured here is the Neopit Power Plant. At least as far back as 1912, the hydroelectric plant at Neopit was able to provide much of the town with light. Hydroelectricity had only begun a few decades prior and remains a rarity today in the United States.

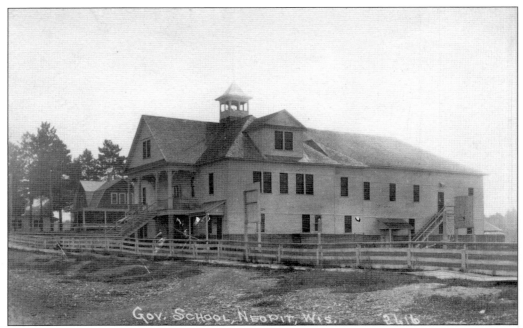

The Neopit School, created by the federal government, also served as an assembly hall and the local gymnasium. Every other Sunday, it would even host church services.

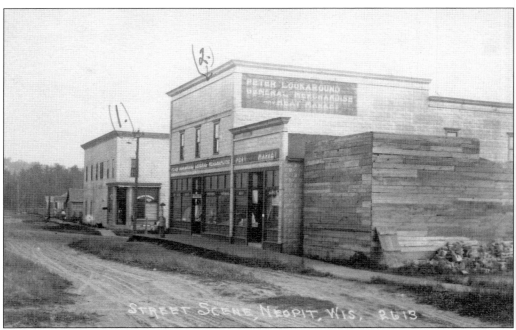

Seen here is an unnamed street in Neopit. Located at (1) is a post office, downstairs in the corner. At (2) is the general store, which also hosted a meat market. The current post office sits in front of St. Anthony's Catholic Church.

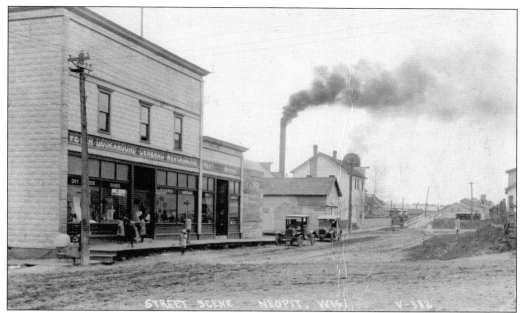

Pictured here is the same street previously seen, but this view looks in the opposite direction. Visible is Peter Lookaround's store, which was the primary business in Neopit at the time and said to be quite successful. A nearby warehouse sold goods at wholesale prices to the local population.

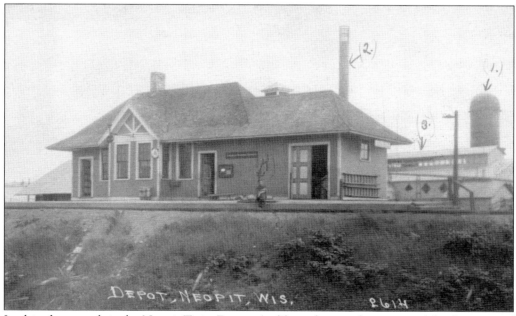

In this photograph is the Neopit Train Depot. At (1) is a burner that was used for disposing of surplus fuel and waste. At (2) is the smokestack from the engine house, (3) is the mill, and (4) is the station agent. Having a train station made Neopit an important stop for trade.

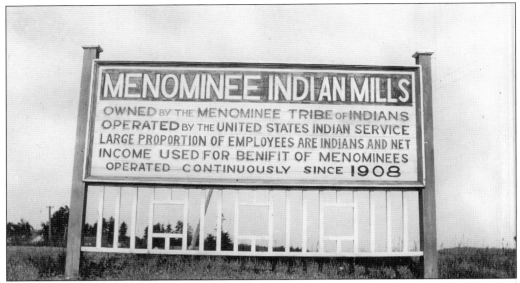

The Menominee Indian Mills sign has a hidden message, and it is not the misspelled "benifit." Notice the distinction of who the owners are and who the operator is. In this case, the operator had more say than the owners.

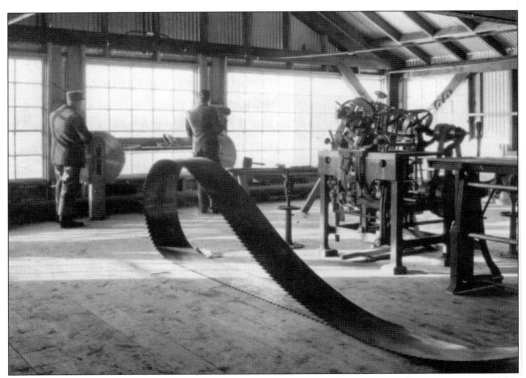

Initially, the government forbade the Menominees to manage their own mill. Beginning in 1930, the tribe sued the government 13 times to get management rights, but was turned down every time. (Courtesy Corbis.)

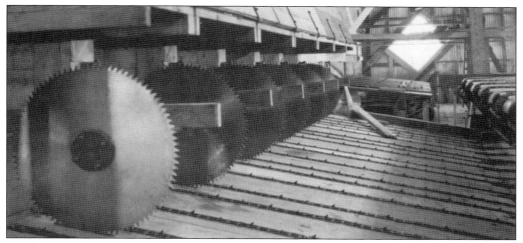

At the sawmill, logs had to be pushed up the slope into the blades in order to be cut. The process was made automated later on, but for a while, only the strongest men could do the job. (Courtesy Corbis.)

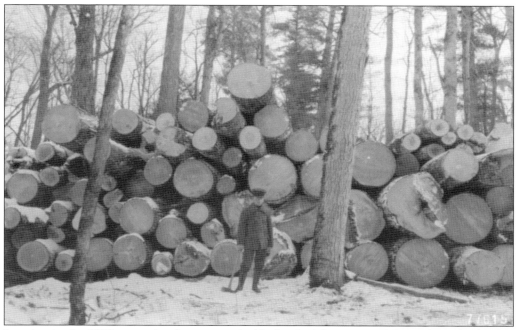

Logging in the 1800s proved to be very profitable for the Menominee. Money from the lumber sales went to build a hospital and a school, and to fund the police and court system. Few other cities can claim a major industry owned by its own citizens. (Courtesy Corbis.)

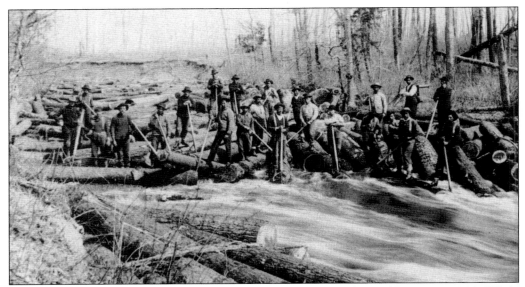

Menominee loggers pose on a logjam on the west branch of the Wolf River in 1886. While reservation life was hard, the logging business boomed and was a positive outcome of the transition. (Courtesy Menominee Tribal Archives.)

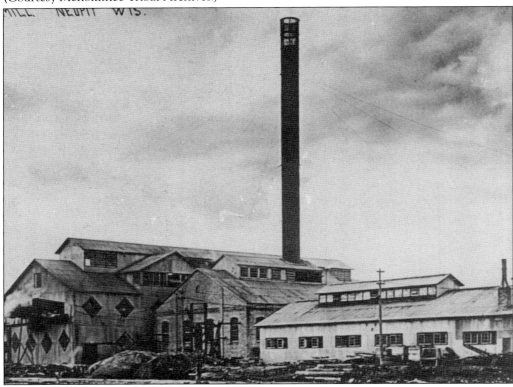

The Menominee lumber mill is seen here in 1910, one year after it was built on the west branch of the Wolf River. An electric plant at the site generated power for the mill and for the town of Neopit, which sprang up nearby as a result of the mill. (Courtesy Menominee Tribal Archives.)

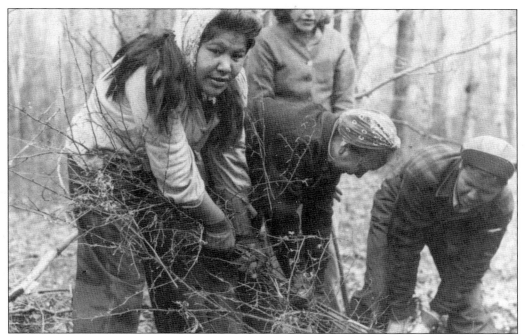

Menominee women clear plants infected with blister rust, a fungal disease deadly to timber stands. During World War II, many women took over their husbands' jobs at the local lumber mill. (Courtesy National Archives.)

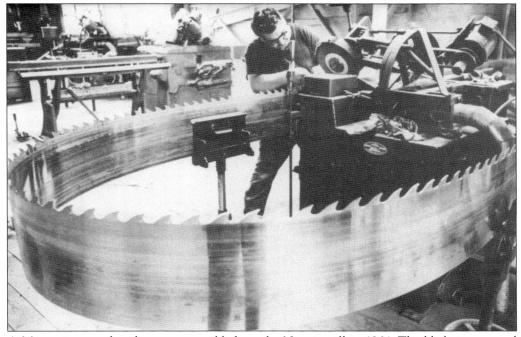

A Menominee worker sharpens a saw blade at the Neopit mill in 1964. The blade is mounted on a power sharpener and was for one of the two huge band saws in the mill. (Courtesy Associated Press.)

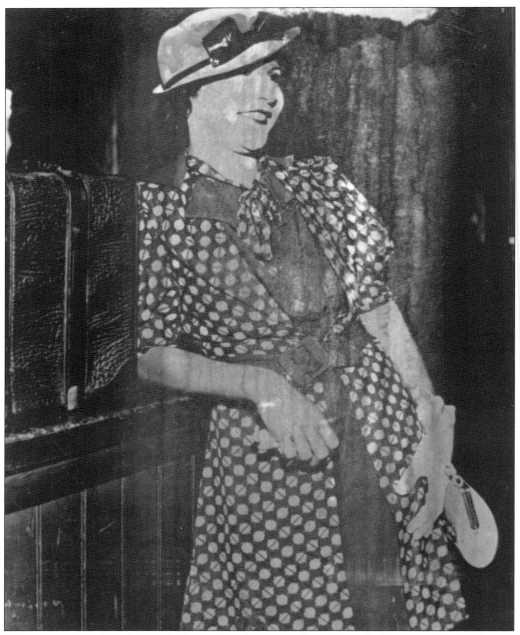

Neopit native Evelyn "Billie" Frechette, best known as the girlfriend of gangster John Dillinger, is pictured at a carnival. One wonders how she might have done at one of those rifle games. (Courtesy Ellen Poulsen.)

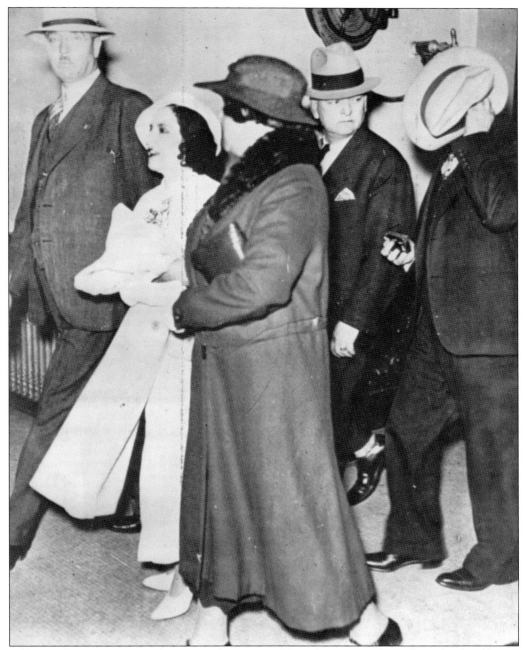

Billie Frechette went on trial in St. Paul in 1934. Although never implicated as a bank robber or getaway driver, she was arrested for helping harbor known fugitives, including Dillinger. (Courtesy Ellen Poulsen.)

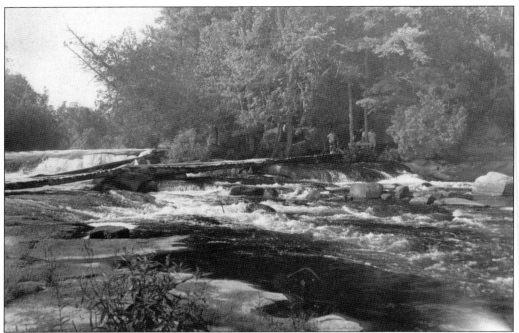

Bear Trap Falls in West Branch is one of the better-known rapids of the Wolf River, located between Crow Rapids and Wayka Falls. It is a bit hard to find (most of Menominee County is forested) but well worth the trouble.

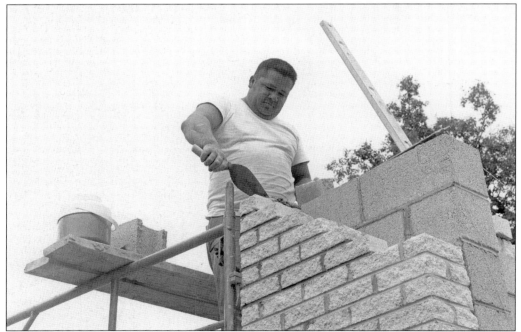

Ron Skenandore is hard at work as a mason. The *Skenandore* name is traditionally associated with the Oneida tribe, but not exclusively. As tribal intermarriage increases, the name origins hold less significance.

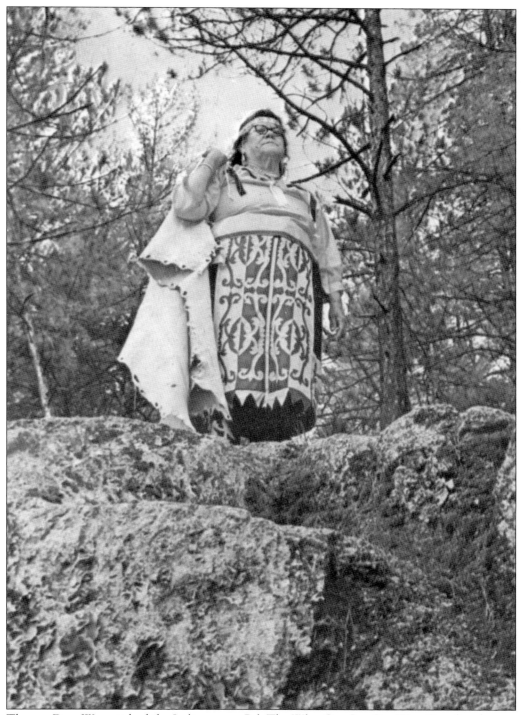

Theresa Deer Wescott had the Indian name Peh-The-Who-Cee-Sac-Coc-Woc. Standing here at the Wolf River Dells in Keshena, she was a teacher of the Menominee language. The first word that she would teach was *posoh* (hello).

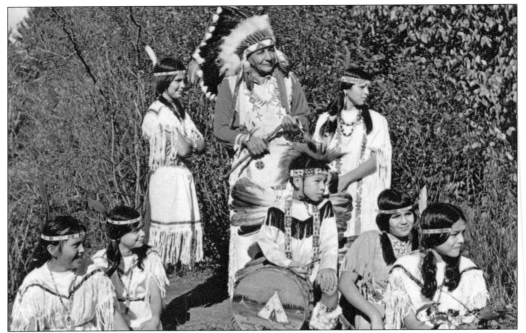

This chief and the schoolchildren surrounding him are pictured on a postcard that indicates they are in Neopit at the "One-Thousand Dollar Bridge" near the Wolf River Falls. (The meaning behind the bridge's name is not clear.)

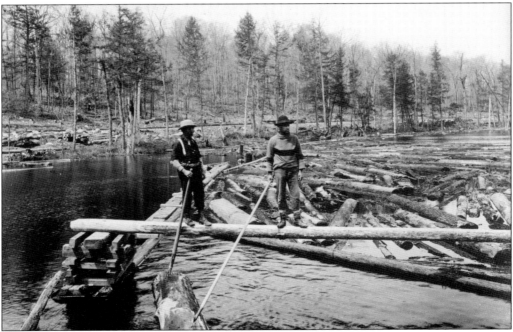

These men are sluicing logs through Pinchot Dam in Neopit, which means they control the rate that the logs can enter the mill. The exact date of the photograph is unknown, but the Pinchot Dam was removed prior to 1912.

The Saturday Islands, located below the Wolf River Dells, can be accessed from Dells Road off of Highway 55, though one might still have to do a bit of hiking.

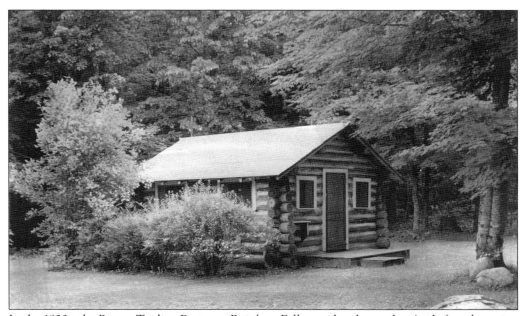

In the 1930s, the Pecore Trading Post near Rainbow Falls was the place to be. Aside from browsing the usual souvenirs and trinkets, visitors could play a game of tennis or even rent a cabin for the night.

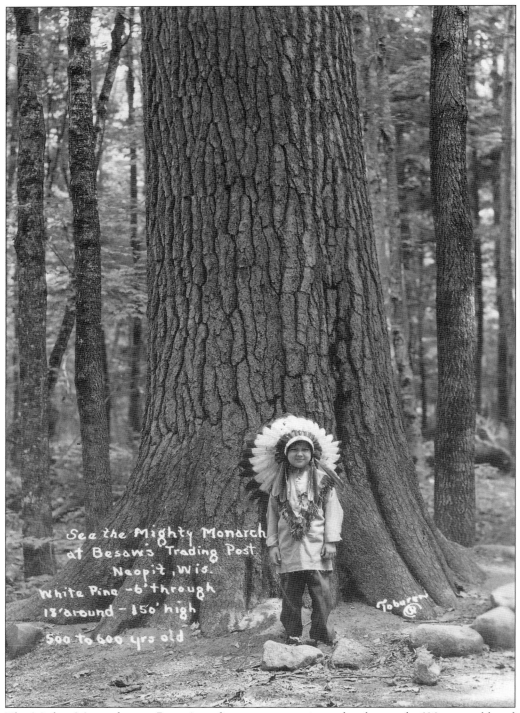

The Mighty Monarch near Besaw's trading post was estimated to be nearly 600 years old and had a circumference of more than 18 feet. If it was truly a white pine as this postcard claims, it was unusually large for the species.

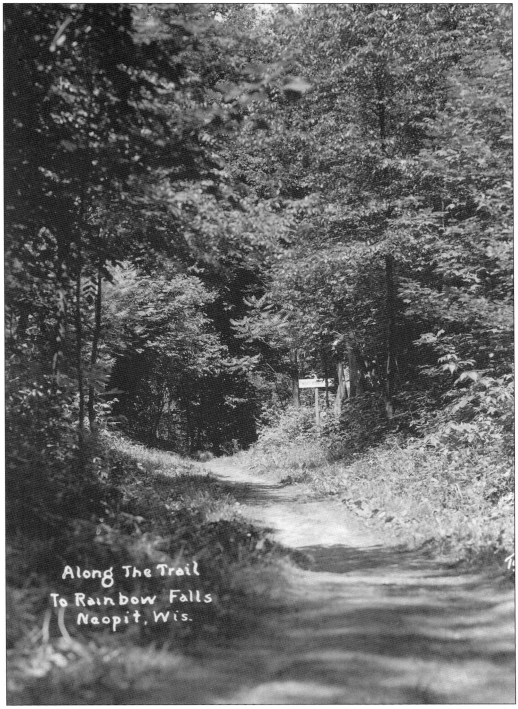

Along The Trail
To Rainbow Falls
Naopit, Wis.

William Otto made this trail to Rainbow Falls and the Pecore Trading Post, most likely in the 1910s. Along the way, hikers will find the Mighty Monarch that extends six to eight arm-lengths in circumference.

Seen here is a young Johnson Beauprey, the uncle of Lucille Chapman (1929–1999). Lucille's father worked at the Indian office, and Lucille proudly served an unprecedented five terms as tribal chairperson. Johnson's parents died when he was a child, and he moved to South Dakota.

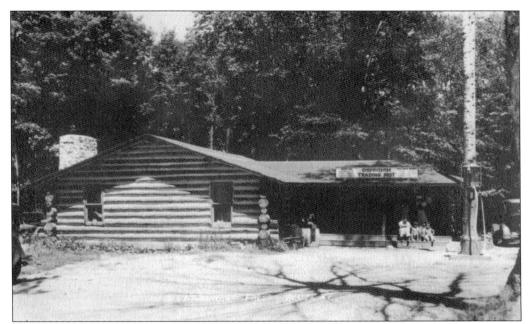

The Oshkosh Trading Post was located at Rainbow Falls on Highway 47 between Keshena and Neopit. This photograph was taken around 1930. Note the unusual gasoline pump on the right-hand side. (Courtesy Shawano Public Library.)

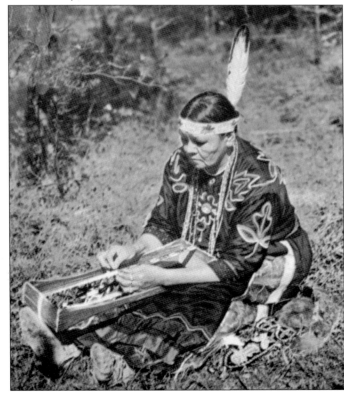

Madeline Smith of Neopit fashions a piece of beadwork while attending the Indian fair in Keshena. She had the distinction of wearing an eagle feather in her hair, a privilege not accorded to every woman of the tribe. (Courtesy Shawano Public Library.)

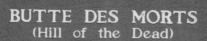

BUTTE DES MORTS
(Hill of the Dead)

In 1730 the French Government decided to destroy the Fox village on the shore of this lake because of the depredations of the Foxes on the fur traders. Capt. Morand came up the river with a large force of French soldiers and Menominee warriors. The soldiers were concealed under canvas until they were opposite the Indians gathered on the shore. Then they rose and fired into the crowd. The Menominees meanwhile attacked the village from the rear. The village was destroyed and its inhabitants slaughtered. The bodies were piled in a heap and covered with earth, forming the Hill of the Dead. In 1827 Governor Cass held a council here with the Winnebago, Chippewa and Menominee tribes to fix their tribal boundaries. At this council Oshkosh was made chief of the Menominees.

Erected 1955

Little Lake Butte des Morts, located in the town of Menasha, was an important French military settlement and was attacked twice between 1716 and 1730. At the time, the Menominees were French allies. The name *Butte des Morts* means "hill of the dead" and may either signify a bloody battle or more likely the location of native burial mounds. The plaque seen here was removed in 2015 because the history it relates is not accurate. (Author's collection.)

Traders Dominique Ducharme and Jacob Franks obtained from the Menominees a 999-year lease on a total of 1,200 acres at Green Bay in 1794, a year after acquiring land in Kaukauna. Of course, it is now known that the natives had no idea what an acre was, nor did they understand the inherent theft of such a long lease. (Author's collection.)

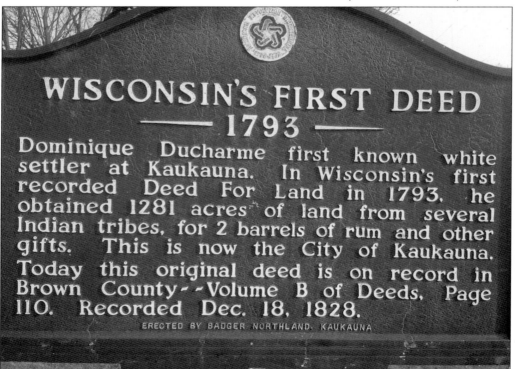

WISCONSIN'S FIRST DEED
— 1793 —

Dominique Ducharme first known white settler at Kaukauna. In Wisconsin's first recorded Deed For Land in 1793, he obtained 1281 acres of land from several Indian tribes, for 2 barrels of rum and other gifts. This is now the City of Kaukauna. Today this original deed is on record in Brown County--Volume B of Deeds, Page 110. Recorded Dec. 18, 1828.

ERECTED BY BADGER NORTHLAND, KAUKAUNA

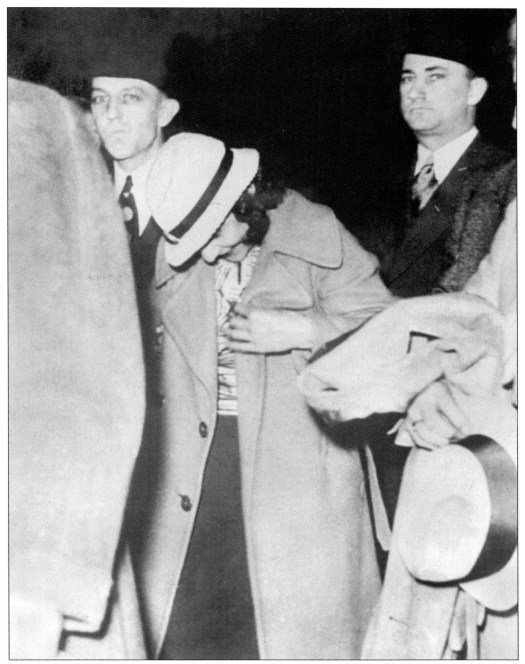

When Billie Frechette was under arrest, the newspapers mistakenly called her "Frechetti," implying she was Italian. In fact, at the time she was dating Dillinger, she was married to another gangster, Welton Spark. (Courtesy Ellen Poulsen.)

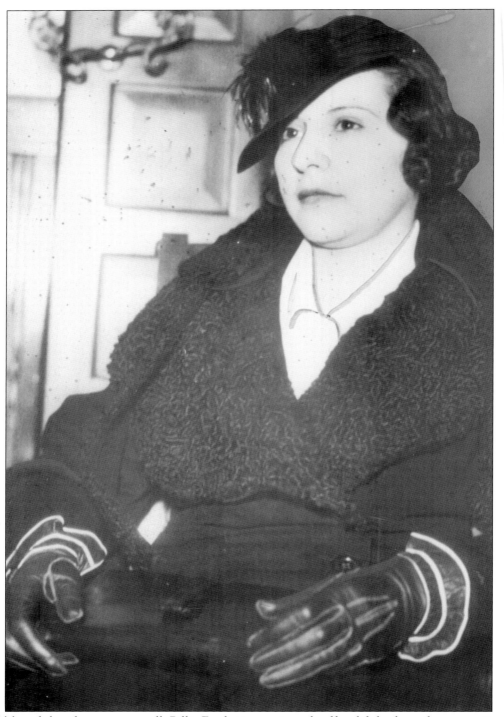

Although best known as a moll, Billie Frechette spent much of her life back on the reservation and was married a few more times to local men before finally settling with barber Arthur Tic (1890–1990) in Shawano. (Courtesy Ellen Poulsen.)

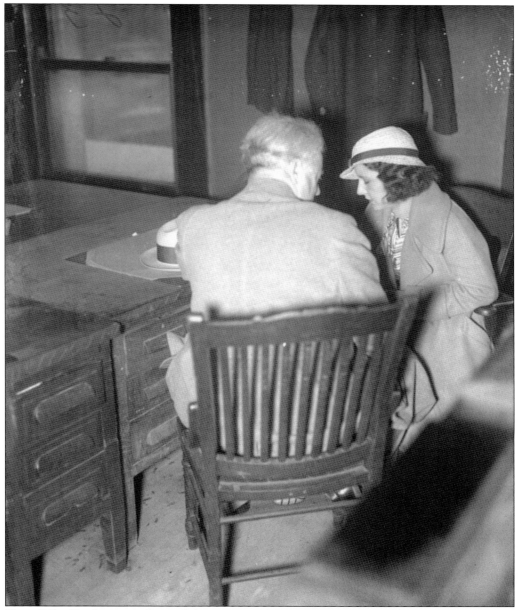

Here, Billie Frechette confers with her attorney. In a strange twist, Frechette ended up touring the country with members of Dillinger's family in a show called *Crime Doesn't Pay* to discourage future lawbreakers. (Courtesy Ellen Poulsen.)

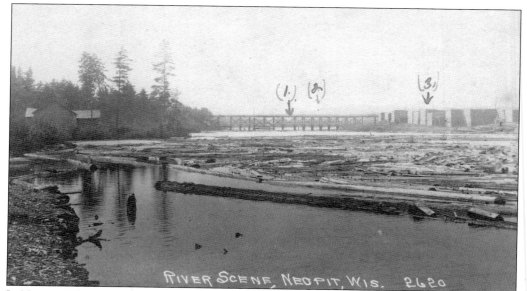

In Neopit is this not uncommon Wolf River scene: logs floating by, waiting for their turn to end up in the sawmill. Although many residents worked in the mill, it was equally important to have men working the woods.

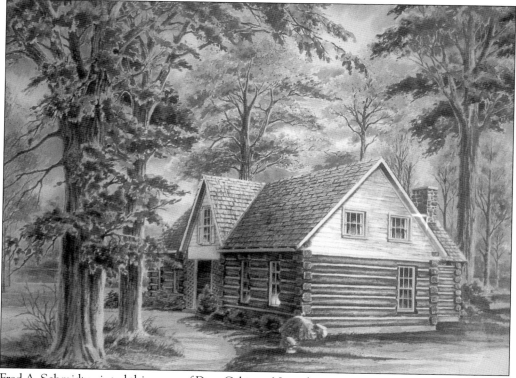

Fred A. Schmidt painted this scene of Doty Cabin in Neenah. James Doty (1799–1865), Wisconsin's territorial governor, had many interactions with the Menominees, as Neenah was an important spot for them to fish.

Four

CULTURE

What defines Menominee culture? As with any culture, it is something that has changed over time, blending with others cultures while still maintaining something of its original flavor.

The Menominee language is a dialect of the Algonquian language family. Though English predominates today, a select group of tribal members has diligently kept the language alive. The classic foods were corn, squash, wild rice, and sturgeon. Wild rice is not nearly so common, but all the others are flourishing, perhaps more than ever.

The homeland has changed, but in a relatively minor way. The acreage shrank considerably, but the biggest gathering place moved only from Marinette to Keshena. Compared to just about every other Native American nation, this was an impressive feat of holding firm and not being pushed aside.

Religion has shifted from beliefs focusing on the Great White Bear to Christianity, but not without retaining some of the old ways. The Dream Dance lives on. And the old Menominee warriors remain warriors today, though now with the Stars and Stripes in the background. Military service is a route for personal achievement and pride, just as always.

Understandably, there is fear that the old ways may someday cease. All parents fear for the next generation and the changing of ideals. But perhaps no existing cultures have seen their way of life vanishing before their eyes more than those of the indigenous people of America. Is it progress or something to mourn?

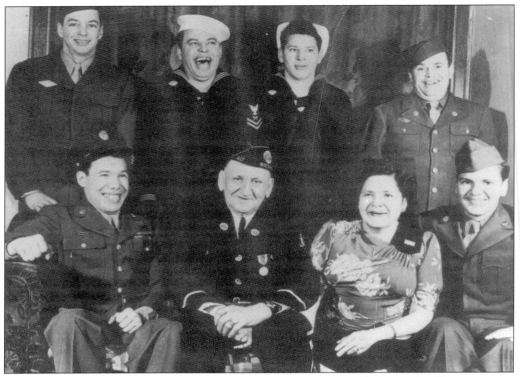

Shown here are, from left to right, (first row) Myron Barney Kelly, Jack Kelly, Eliza Gristoe Kelly, and John Kelly; (second row) Al Kelly, Marvin Turney (born 1914), Irv Kelly (born 1924), and Elmer Turney.

Pictured here are Aloysius Paul LaRock (born 1926), of the United States Navy, and his mother, Mary Ann Cardish LaRock (1890–1974). Aloysius married Marguerite Frechette.

Cpl. Claire Ann Tucker (1935–2014), a US Marine who served in Vietnam, was the first female Menominee Marine. She is seen here celebrating Christmas at her grandmother's house in Neopit.

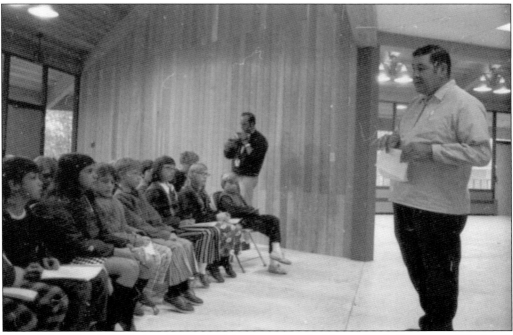

Hilary John "Sparky" Waukau (1922–1995) is pictured at the Nature Study Sanctuary. Waukau is now in the Wisconsin Conservation Hall of Fame for fighting to prevent a Crandon-area sulfide mine proposed by Exxon Corporation as well as a proposed nuclear waste dump.

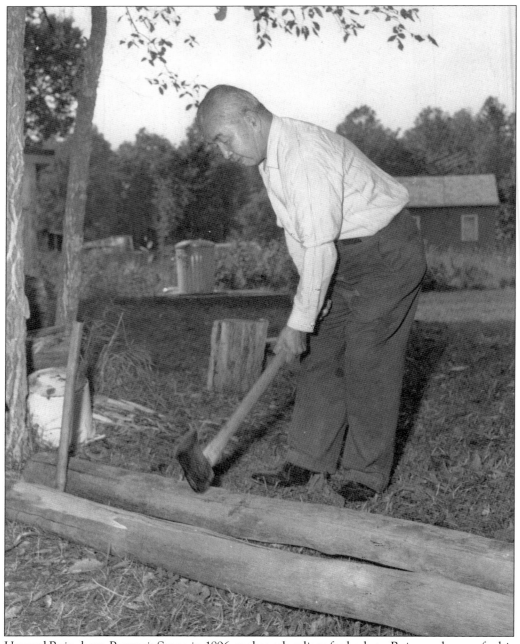

Howard Rain, born Peawasit Stone in 1896, makes ash splints for baskets. Rain was known for his religious use of peyote as well as performing tribal dances with companion Summer Cloud.

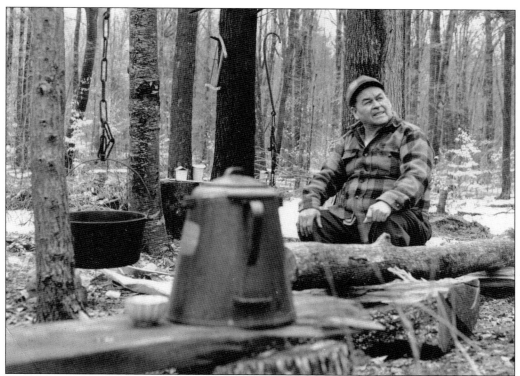

Jerome "Sanome" Sanapaw (1914–1979) is boiling maple sugar. Professionally, he was a woodworker. Each spring, he would fill a near-endless amount of buckets with sap, which made for a great seasonal business.

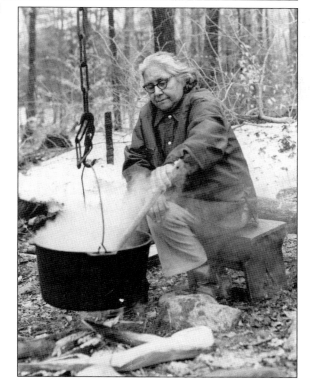

Merceline K. Sanapaw (1914–1984), seen here stirring maple syrup, was Jerome's wife and, along with Wallace Pyawasit and Margaret Richmond, she contributed samples of the Menominee language to the California Language Archive at Berkeley.

Joseph N. Brazgel (1934–2014), a veteran of the US Air Force, lived in Shawano, where he enjoyed hunting and fishing. Although Brazgel was Polish, he married into the Menominee community.

Pictured here is a Dream Dance drum. Followers of the Dream Dance religion believed that bad dreams could make a person sick, and the only way to exorcise the body of its demons was to act out the bad dreams through dance. (Author's collection.)

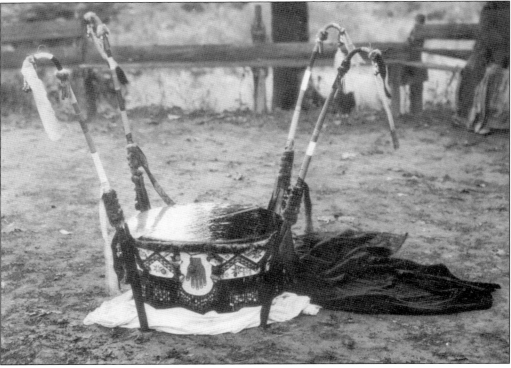

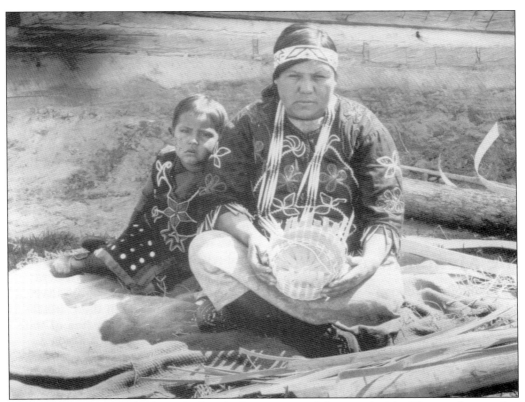

A Menominee woman displays a basket she has woven and decorated with ribbon and porcupine quills. When dyed, the quills could make a variety of durable goods, and some people to this day carry on the tradition. (Author's collection.)

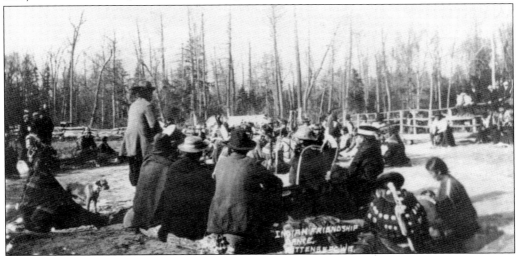

Traditionally, the Menominees would meet twice a year with other tribes to have a powwow and discuss tribal matters, as well as form new bonds and friendships. The meeting shown here took place in Wittenberg, west of Shawano, probably with the Ho-Chunk people. (Courtesy Minnesota Historical Society.)

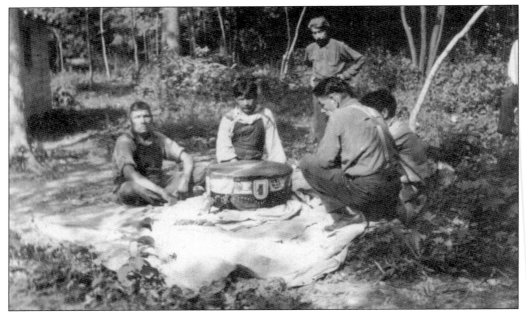

A group of Menominees is seated around a Dream Dance drum. In the 1880s, the Dream Dance (which combined Christian and Indian elements) became a popular way to embrace tradition, as the reservation felt increasingly threatened by non-Indians. (Courtesy Wisconsin Historical Society.)

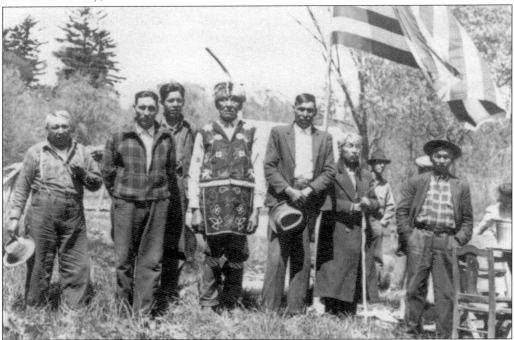

The Menominees gathered in the town of Zoar on May 16, 1942, for a patriotic ceremony. During World War II, more than 200 Menominees served in the armed forces, which was a sizable percentage of the population. (Courtesy National Archives.)

Nessie Fish Wishkeno (1889–1984) was known for her quill basketry. In 1966, she published her memoirs, describing a devastating fire she survived as a youth and her arranged marriage at age 13.

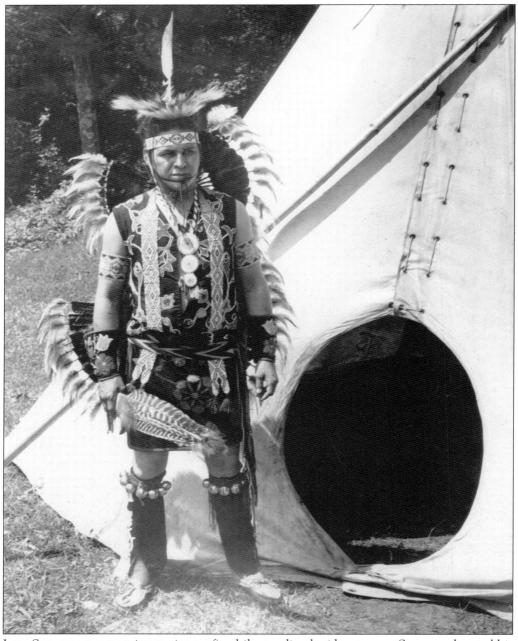

Jerry Sanapaw wears an impressive outfit while standing beside a teepee. Sanapaw donated his family's handmade wooden syrup ladle to the Menominee Cultural Museum. Utensils were fashioned out of birch bark.

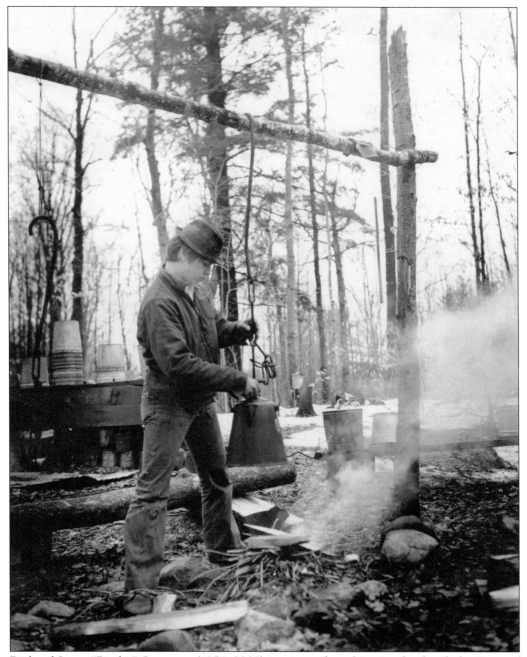

Richard Leon "Rocky" Sanapaw (1954–2009) is pictured working in the family business of harvesting maple syrup. Rocky was a veteran of Vietnam, having preferred to enlist in the Navy rather than get chosen by the draft.

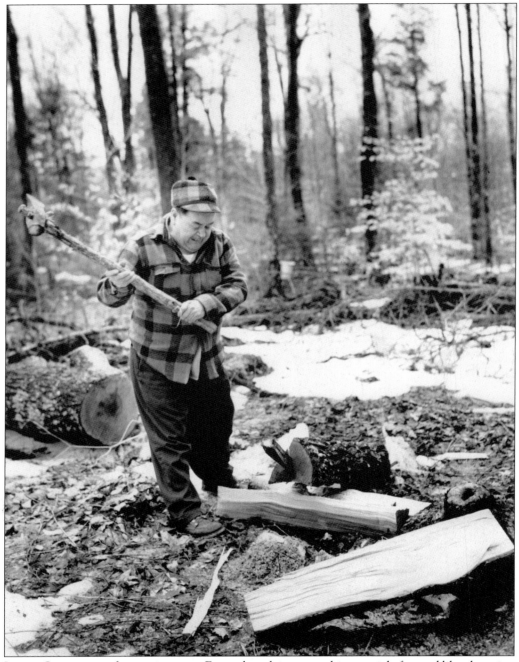

Jerome Sanapaw is a fascinating man. Even when doing something straightforward like chopping wood, he does it his own way—with a homemade ax. This tool is very much an extension of a classic Menominee weapon: the ball club.

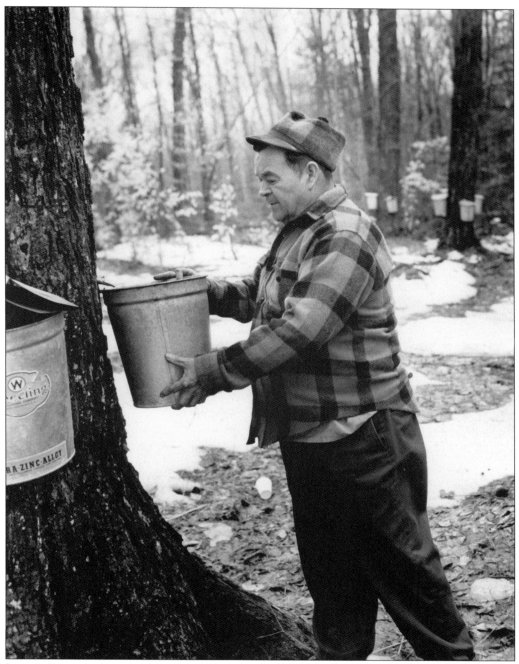

Jerome Sanapaw is gathering one of his many buckets filled with sap for maple syrup. Today, syrup comes in a variety of grades and colors, but originally, there was only one kind—that of Sanapaw's ancestors, the northern native peoples.

John Munson (1923–2012) loved acting as a guide on the reservation and referred to himself as "Namakee" (thunder). A bit of a dreamer, after serving in both World War II and Korea, he attended Layton School of Art in Milwaukee.

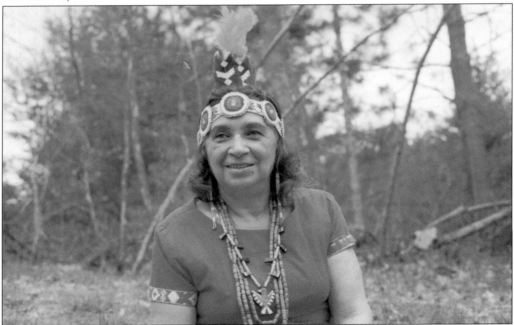

Irene Mack was a political leader in the 1970s, having been chosen by the tribal council to represent them in Washington, DC. She was a feminist and Indian activist, wary of the white man's offers of friendship—based on history.

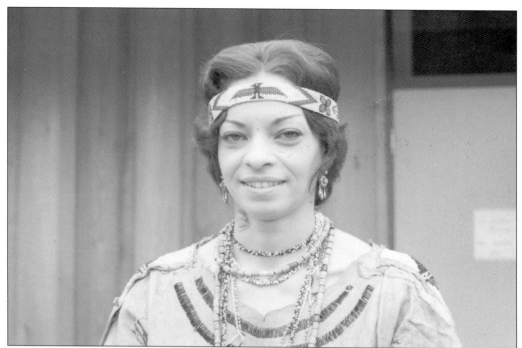

Littie Dixon, like Irene Mack, was an important female leader. They were both ritual apprentices of the Drum Dance religion. Dixon got involved in spiritual matters through her husband's stepfather, Wallace Pyawasit.

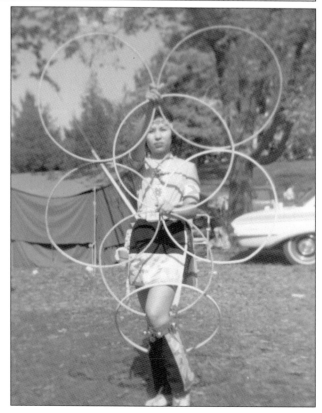

Opal Skenandore has a way with hoops that could put anyone to shame. She was athletic her whole life, once playing on the Milwaukee Bravettes, an all-Indian female baseball team.

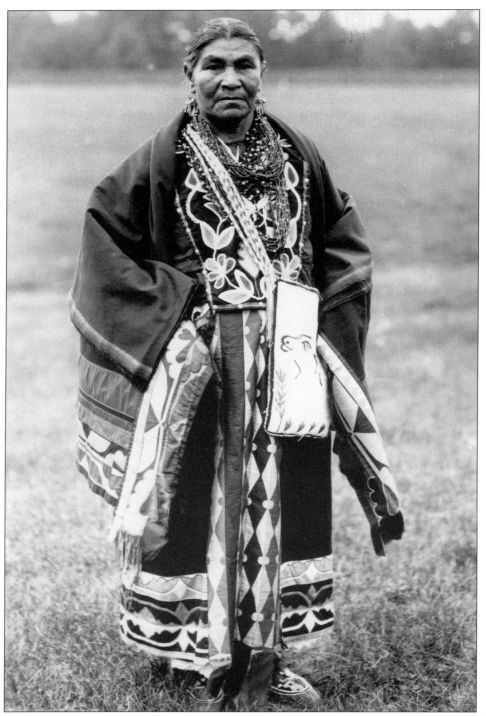

Louise Amos was a real-life medicine woman. In different Native American cultures, a medicine woman could heal the sick or even exorcise demons.

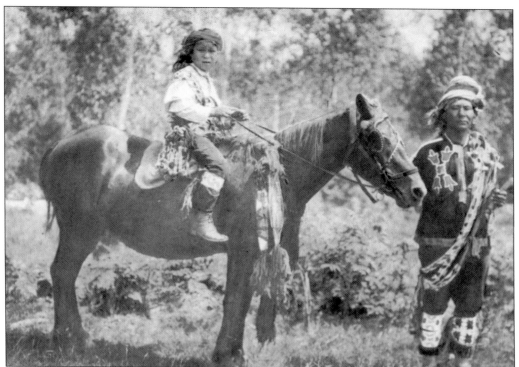

John Amob (born 1866) and his son Joseph (born 1895) are featured on the postcard above. The writer notes that they "did not neglect their horse; it too has been decorated with finely woven and fringed sashes." John was said to be the best hunter in the tribe. At right is another image of John and Joseph. The club being held by John was allegedly passed down to him by his ancestors and was said to have been used at the Siege of Fort Detroit in 1763. That one battle lasted five months.

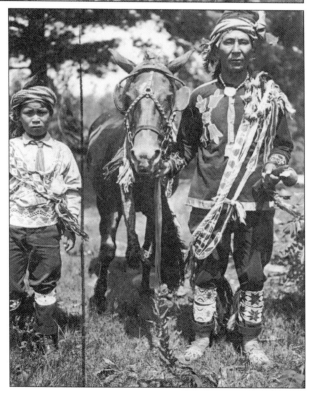

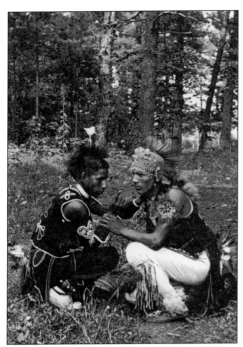

The postcard notes this staged "consultation" was at the Nomad Trading Post in Markton (located north of the reservation). The man on the right is identified as White Feather, who was actually Ojibwe (another group of Algonquians).

Because of her stature in the Indian community, LaDonna Harris (born 1931), founder and president of Americans for Indian Opportunity, was pivotal in getting the Menominee reservation restored and worked alongside Ada Deer. Harris, a Comanche, believed that all American Indian nations ought to work together to achieve common objectives. (Courtesy Wisconsin Historical Society.)

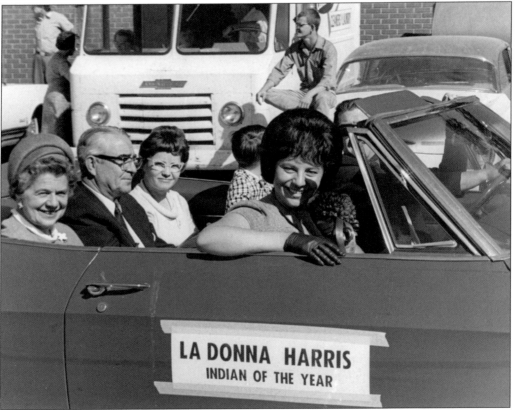

LA DONNA HARRIS
INDIAN OF THE YEAR

Seen here is another view of the outfit worn by Louise Amos, medicine woman. It was common for the knowledge of medicine and spiritual healing to be passed from parent to child, making the title often inherited.

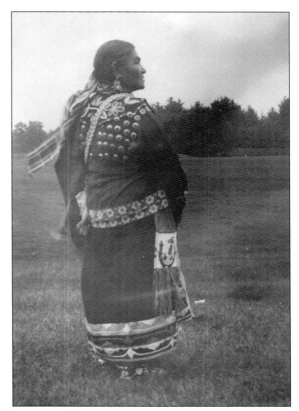

Harmon Percy Marble (1870–1945) took this photograph of a Menominee family harvesting maple syrup in 1915. He was an employee of the Indian Agency first and a photographer second, but his camera work is now immortalized.

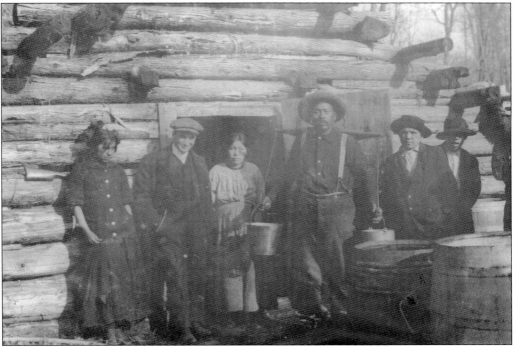

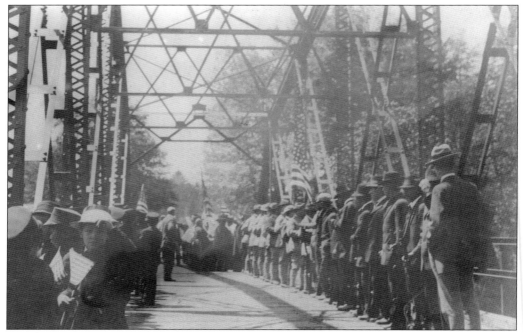

Another image from Harmon Percy Marble, this one features Menominee soldiers preparing to go off to fight in World War I. After retiring from the Indian Agency, Marble went on to become the mayor of Las Vegas, Nevada, where he was a champion of the poor.

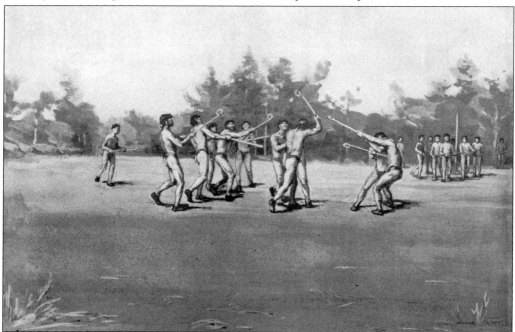

This depiction of lacrosse players shows the middle of a particularly exciting and animated game. Although lacrosse was primarily for recreation, it also could build team relations and enforce the tribal dynamics. Today, lacrosse is played at all levels—from youth to professional leagues.

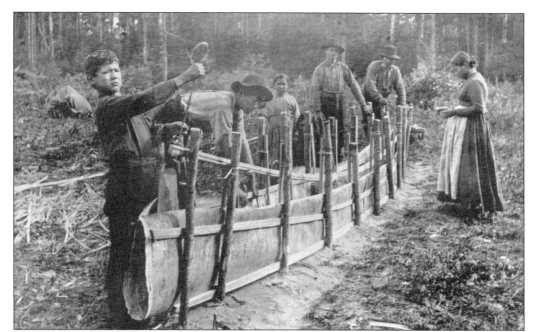

Many people are necessary in setting up a bark canoe. One has to marvel at the ingenuity of the canoe, with its curves and ribs. Being able to float and support its crew, without any of the modern fasteners like rivets, is a real achievement.

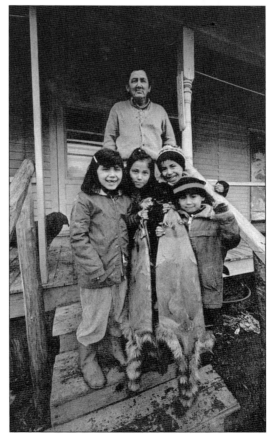

Carl Johnson Maskewit and his children show off the pelts of raccoons that Maskewit caught and skinned. Although the fur trade is long gone, selling pelts as souvenirs has been a great way to make extra money. (Courtesy National Geographic Society.)

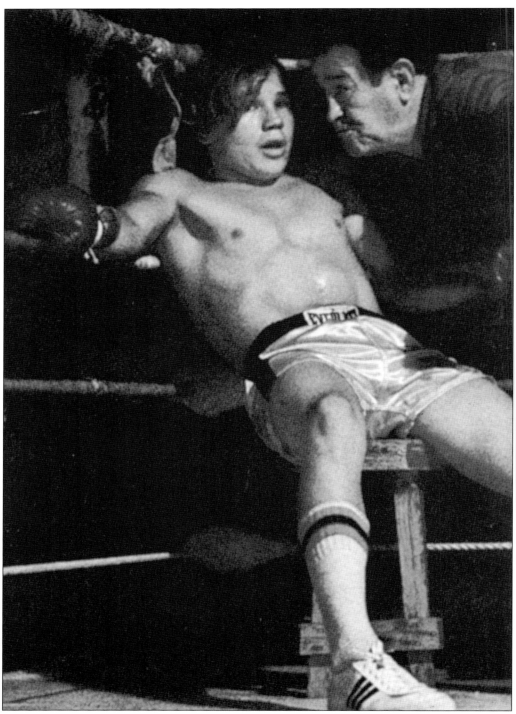

Boxer Marvin "Wheeler" Pamonicutt (1955–1985) rests on the ropes while being guided by his coach, Alex Askenette (1922–2003). This particular fight, which took place in the early 1970s, was won by Pamonicutt. (Courtesy National Geographic Society.)

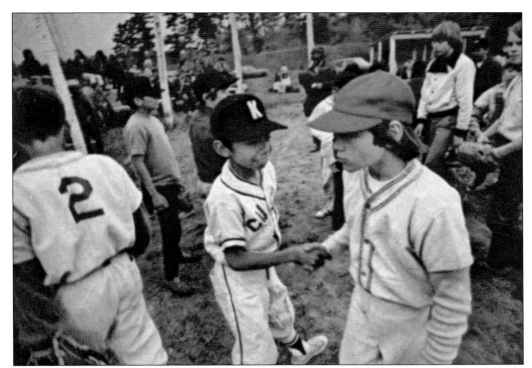

Mike Peters, a Little Leaguer on the Keshena Cubs team, honorably smiles and shakes the hand of a Red River player. Not every game can be a win—especially when the team is named after the Chicago Cubs. (Courtesy National Geographic Society.)

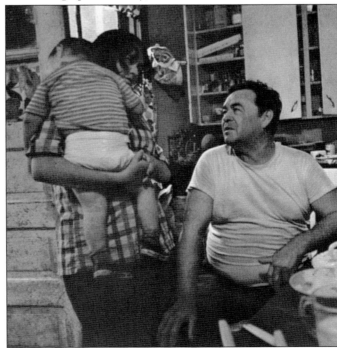

Sanome Sanapaw (right) and daughter Leona have just finished a dinner of bear steak, wild rice, and fry bread. In the 1970s, the Sanapaws were one of the last families to use wild rice as a staple. (Courtesy National Geographic Society.)

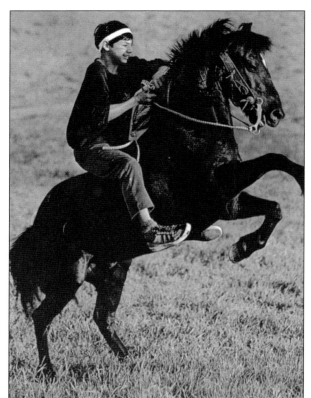

This Menominee youth practices his horse-riding skills at Thunderbird Ranch, a foster home specifically designed to encourage motivation and self-esteem in the next generation. (Courtesy National Geographic Society.)

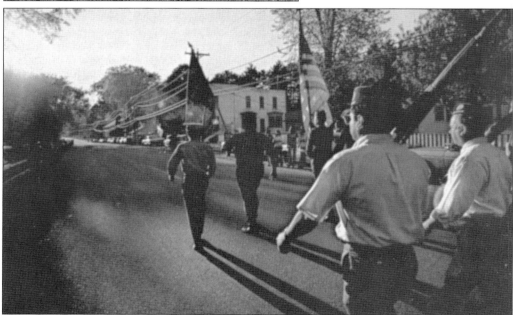

They were "American" before there was an America. The local American Legion celebrates Memorial Day, and the tribe remembers its American soldiers, some dating back to the Civil War. (Courtesy National Geographic Society.)

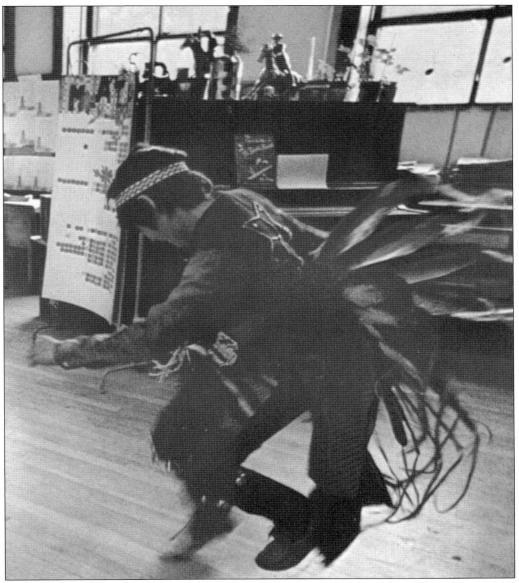

An impeccably dressed Kenneth Dodge shows off his dancing skills for the students of St. Joseph's in Keshena. The Sisters of St. Joseph of Carondelet operated St. Joseph's School from 1883 to 1980, when it closed. (Courtesy National Geographic Society.)

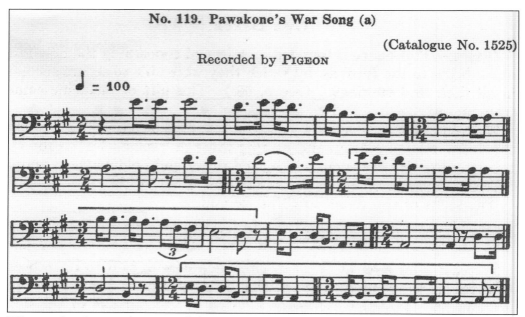

When early ethnographers visited the Menominee, they wrote down many of their songs. This pleasing tune came from Pawakone (Falling Feather) and was used to motivate warriors who were going into battle.

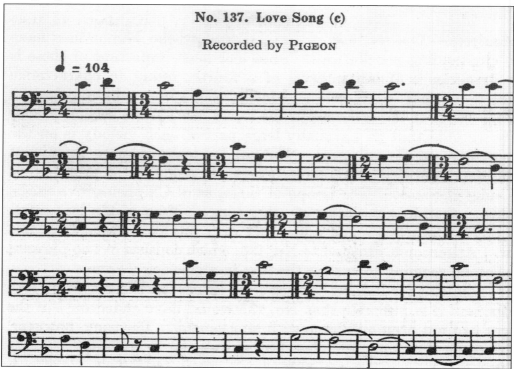

Menominee songs could express the full range of emotions. The lyrics to this love tune roughly translate as, "Do not weep for me, my sweetheart, for you will see me in the springtime."

Five

MODERN HISTORY

The modern history of the Menominees, during the second half of the 20th century, is predominated by two large events in Menominee history: the termination of the reservation and the restoration several years later.

Congressional passage of the Menominee Termination Act of 1954 removed federal recognition of the tribe and threatened to deprive the Menominee people of their cultural identity. This lack of federal protection brought in outside land developers who were more concerned with turning a profit than preserving the unique beauty of the surrounding forests and other natural wonders.

The leader of the termination movement in Congress was Sen. Arthur Vivian Watkins (1886–1973). A Mormon, he had a deep respect for the native peoples and thought of termination as a modern Emancipation Proclamation. Although driven by the best of intentions, his plan did not work as he envisioned. Suddenly, the champion of native rights had become a villain.

Fortunately, the tribe won back its federal recognition in 1973 through a long and difficult grassroots movement that culminated with the passage of the Menominee Restoration Act on December 22, 1973. The Menominees can proudly say they won the fight through civil disobedience and legal action and never had to resort to outright violence. In an era of great civil unrest (the late 1960s), this was an achievement in itself.

Progress has been steady since then, with the creation of the College of the Menominee Nation, allowing for the people to better themselves and get started on advanced careers. And of course, there is the casino, which has been an excellent source of income where outsiders come from miles around for a chance to test their luck. (Just remember, in gambling, the house always wins.)

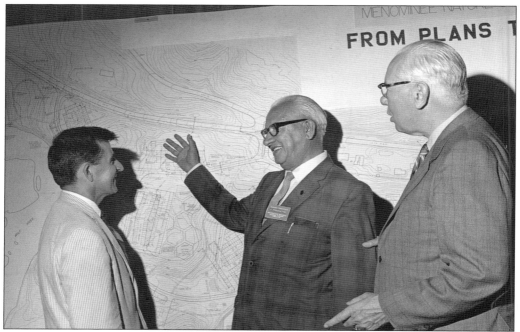

Tribal delegate James G. Frechette (1900–1980), center, points to the plans. His son James F. Frechette (1930–2006) carved the *Great Silvery White Bear* on permanent display at the College of Menominee Nation. The two other men pictured here are unidentified. (Courtesy Menominee Public Library.)

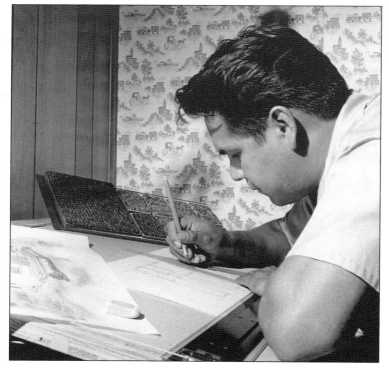

Donald R. "Donnie" Weso (1940–1988) studied architecture. Weso's father, Monroe Weso (1904–1983) was a tribal delegate and had the honor of being present when Pres. Dwight D. Eisenhower signed the Menominee self-government agreement in June 1954. (Courtesy Menominee Public Library.)

Ada Elizabeth Deer (born 1935) was an activist opposing federal termination of tribes in the 1970s. She was appointed as assistant secretary of the interior, head of the Bureau of Indian Affairs, serving from 1993 to 1997. (Courtesy the Hulton Archive.)

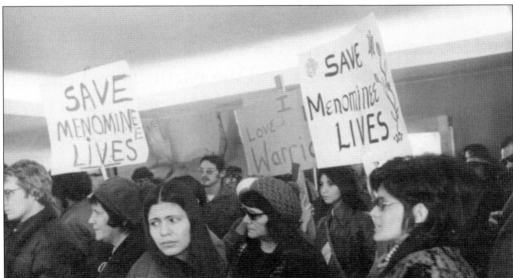

A group of Menominees is protesting termination. When the reservation was terminated, the sudden impact of taxes caused many natives to loss their homes and land. Menominee County quickly became the poorest county in the state of Wisconsin. (Courtesy Corbis.)

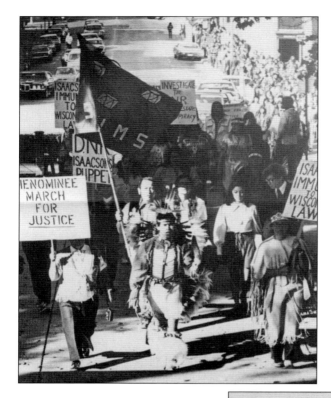

In October 1971, a group of Menominees walked 222 miles from Keshena to Madison in the March for Justice, protesting termination and the Legend Lake Project. Some signs denounced N.E. Isaacson of Reedsburg, the project developer. (Courtesy Associated Press.)

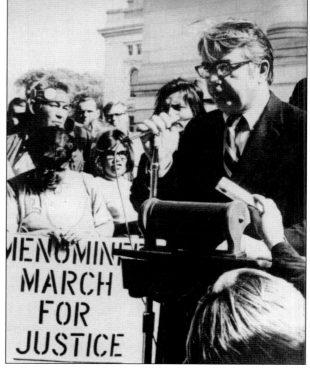

Gov. Patrick Lucey met the March for Justice protestors on October 14, 1971, at the steps of the state capitol. Lucey pledged to visit Keshena, and did just that two weeks later. What he saw caused him to throw his support behind the restoration of the reservation. (Courtesy Associated Press.)

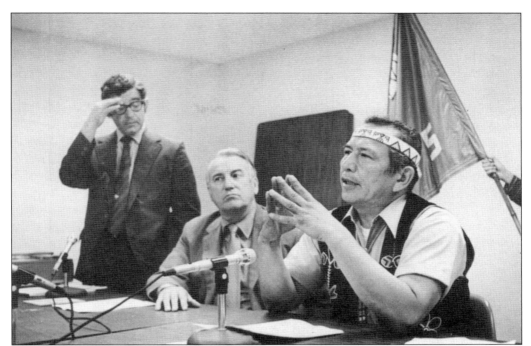

DRUMS spokesman James White outlines his objections to the Legend Lake Project in October 1971 during a meeting with the Department of Natural Resources. (Courtesy Associated Press.)

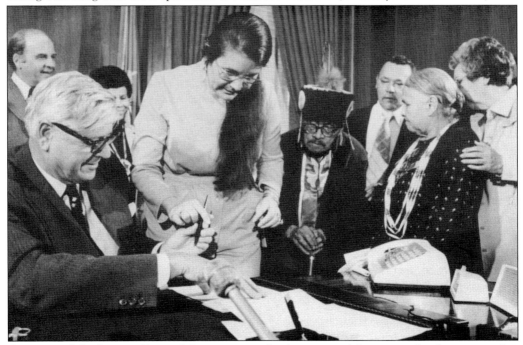

Secretary of the Interior Rogers Morton signs a deed returning Menominee land to reservation status at ceremonies in Washington, DC, on April 23, 1975. Ada Deer and tribal elder Ernest Neconish look on. (Courtesy Associated Press.)

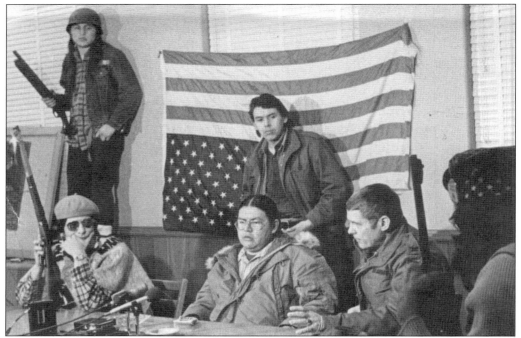

On January 1, 1975, members of the Menominee Warrior Society (MWS) occupied an abandoned Catholic monastery near Gresham, Wisconsin, to protest their condition. A standoff lasted for 34 days between the MWS and 750 National Guardsmen under the command of Col. Hugh Simonson. (Courtesy the Bettmann Archive.)

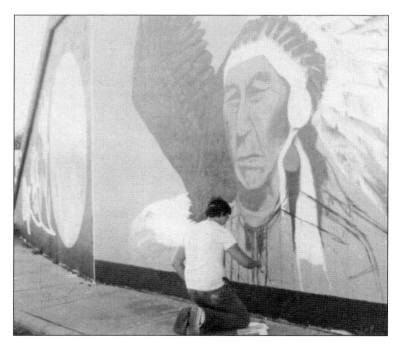

As the Menominee people move forward, they continue to honor their past. Here, local artist Lyle Tucker (a graduate of the School of the Art Institute of Chicago) paints a scene on the side of a trestle in Neopit. (Courtesy *Menominee Tribal News.*)

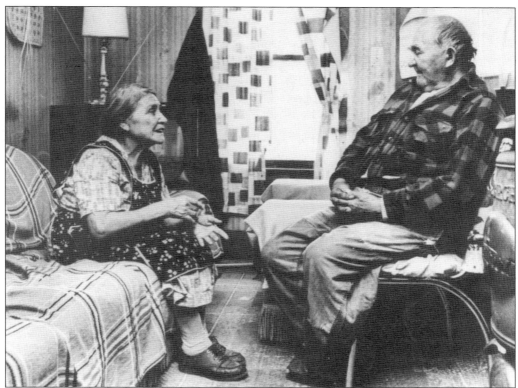

An elderly Menominee couple is pictured in a two-room house they rented for $15 per month. Taken in 1964, this photograph shows just how quickly poverty and economic decline hit the Menominees following the reservation's termination. (Courtesy Associated Press.)

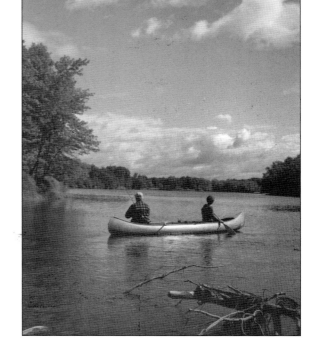

This image of unidentified canoeists really captures the beauty and majesty of the Menominee reservation. The greatest resource the tribe has is its many acres of woodland, lakes, and rivers. The true value is in not developing it.

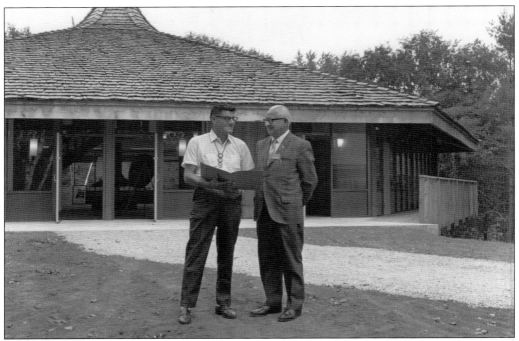

Ben Miller (left) was the tribal and county chairman in the 1970s and testified before Congress in order to get the tribe's reservation restored. Standing beside him is Jim Frechette, who appears elsewhere in this book.

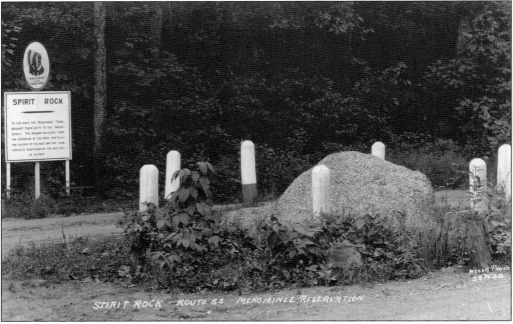

The legend of Spirit Rock says that the Menominee people will survive as long as the rock does. In a warning about assimilation, the rock has slowly been eroded, and it is much smaller today than even a mere decade or two ago.

Each year, the tribe hosted the Menominee pageant, complete with songs, dances, and various acted out skits. Angus Lookaround was born Phebe Jewell Nichols and was not an Indian, but she vociferously supported the tribe's causes.

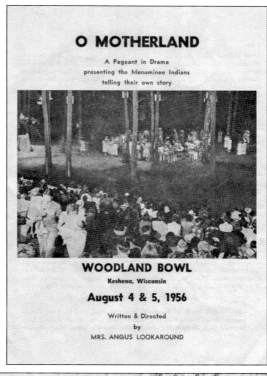

O MOTHERLAND

A Pageant in Drama
presenting the Menominee Indians
telling their own story

WOODLAND BOWL
Keshena, Wisconsin

August 4 & 5, 1956

Written & Directed
by
MRS. ANGUS LOOKAROUND

When the tribe's status was terminated, outside developers came rushing in, believing their money could purchase all the "new" land. Here is a plat of Bass Lake, where the plan was to encircle the entire lake with cottages, restricting access for nonresidents.

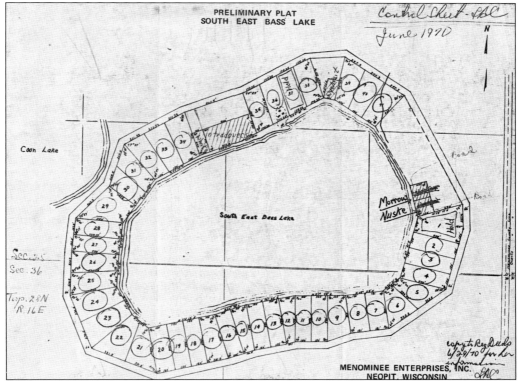

PRELIMINARY PLAT
SOUTH EAST BASS LAKE

MENOMINEE ENTERPRISES, INC.
NEOPIT, WISCONSIN

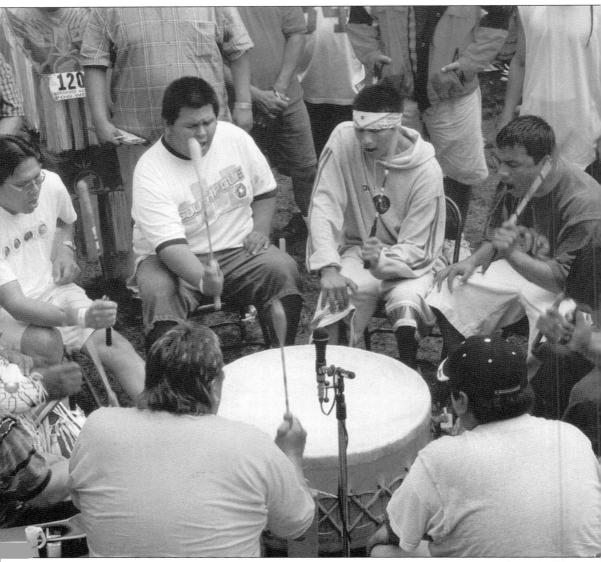

In the 21st century, more and more traditions are fading. Now, there are T-shirts and baseball caps where there were once feathers and beads. But in some ways, such as this drum circle, the old ways carry on.

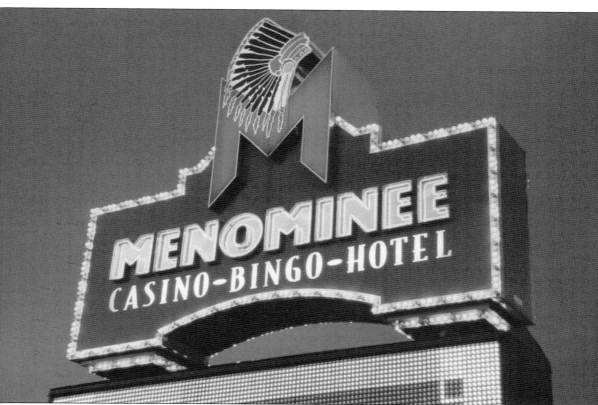

Legalized gambling has been a boon for the reservation. People throughout Wisconsin travel for miles to spend their money at the casino, and the profits go towards the school system and other social services.

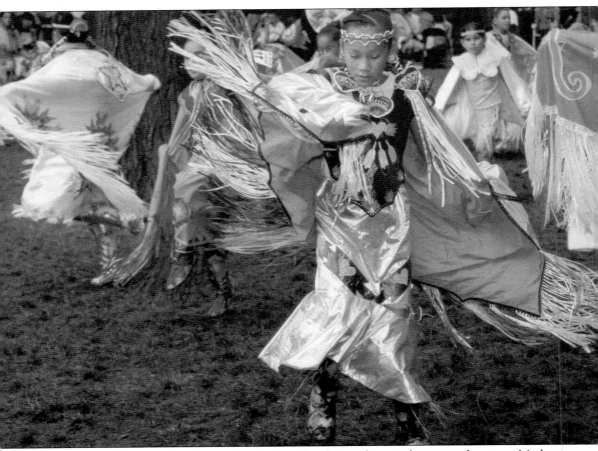

Although there is much to lament in the loss of tradition, there is also some advantage. Modern textile work allows the costumes of dancers and other celebrants to be more vibrant and colorful than ever before.

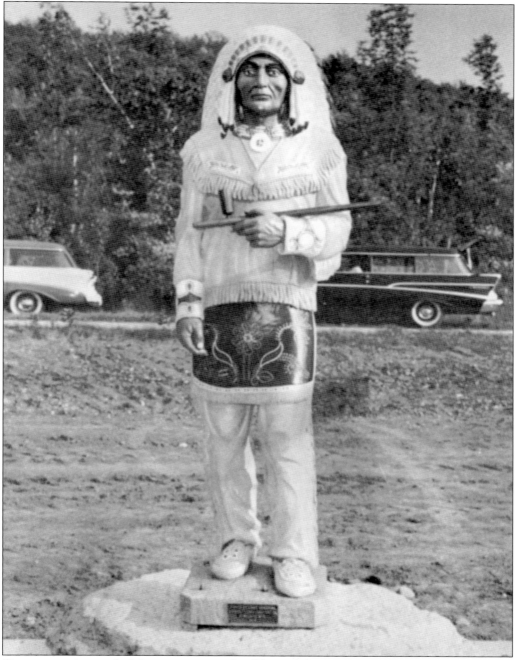

Commemorations to the Menominees extend well beyond the reservation, sometimes in unexpected places. This statue of Roy Oshkosh can be found in Egg Harbor, in Wisconsin's Door County. Roy, a grandson of the well-known chief, was prominent in the tourist haven.

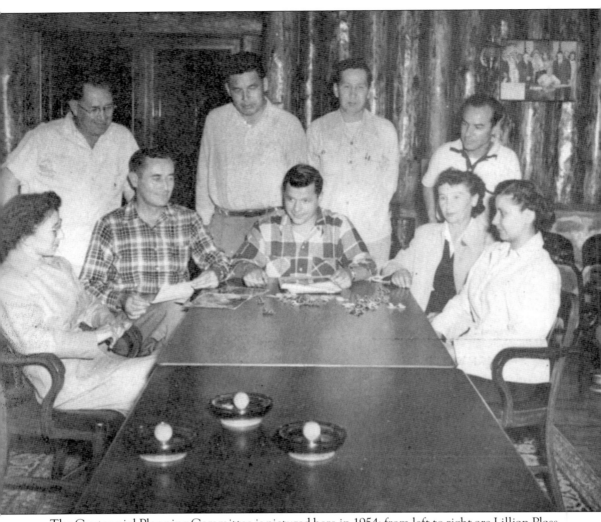

The Centennial Planning Committee is pictured here in 1954; from left to right are Lillian Plass, Joseph Warrington, Gordon Dickie, John Fossum, Gordon Keshena, Tom Grignon, Robert Ladd, Jennie Weso, and Marie Bowan. (Courtesy Shawano Public Library.)

CONGRESS OF THE UNITED STATES

House of Representatives

Washington, D. C.

June 24, 1954

To all Members of the Menominee Indian General Council

Menominee Indian Reservation

Keshena, Wisconsin

Dear Friends:

Congratulations are indeed in order to all of you on this One Hundredth Anniversary. I have been proud and privileged to have made a contribution to the history of your Tribe here in our Nation's Capital. As the Representative in Congress of the Menominee Indian people, I have done my best to protect your rights and obtain fair and equitable treatment not only by the Congress but in the Executive Departments of our Federal Government.

The future of the Menominee Indian people can indeed be bright as you have demonstrated time and again your great ability to manage the affairs of your tribe in an effective and efficient manner. Menominee Indians have opened a new era in Indian affairs; you have blazed a trail for the Indian people to follow throughout our Country.

You are strengthened by the knowledge and experience of the past and by your courage for the future and it is my wish that the future may be happy and peaceful for all of you.

Respectfully yours,

MELVIN R. LAIRD

Member of Congress

Melvin Laird (born 1922) wrote this letter to celebrate the "centennial" of the treaty that created the Menominee reservation, coincidentally just before it was to be dissolved. Congressman Laird was later Pres. Richard Nixon's secretary of defense and was instrumental in ending the Vietnam War. (Courtesy Shawano Public Library.)

IMMEDIATE RELEASE June 17, 1954

James C. Hagerty, Press Secretary to the President

THE WHITE HOUSE

Statement by the President

I have today signed H.R. 2828 which provides for the method of terminating Federal supervision over the property and affairs of the Menominee Indian Tribe of Wisconsin on December 31, 1958. This bill, developed after extensive consultation with the Menominee people over a period of many months, is the first to be enacted into law as an outgrowth of the Congressional policy on Indian affairs which was embodied in House Concurrent Resolution No. 108 adopted last summer. That policy calls for termination of Federal supervision over the affairs of each Indian tribe as soon as it is ready for independent management of its own affairs.

The Menominees have already demonstrated that they are able to manage their assets without supervision and take their place on an equal footing with other citizens of Wisconsin and the Nation. I extend my warmest commendations to the members of the Tribe for the impressive progress they have achieved and for the cooperation they have given the Congress in the development of this legislation. In a real sense, they have opened up a new era in Indian affairs—an era of growing self-reliance which is the logical culmination and fulfillment of more than a hundred years of activity by the Federal Government among the Indian people.

In the four and one-half years which remain before Federal supervision is terminated, the Menominee Tribe has authority to employ any specialists it may need in developing plans for a sound business organization to carry on the tribal enterprises. The Tribe will also have the active assistance of the Department of the Interior and the State of Wisconsin during this important period of preparation for full and final independence.

All of the problems of withdrawal of the Federal Government from the field of Indian administration have not been solved by the enactment of this one bill. Nevertheless, I am sure that it will provide useful and sound guide lines for authorizing other Tribes to realize their full potentialities as productive citizens of the United States whenever they can advantageously assume complete responsibility for the management of their affairs.

A letter from President Eisenhower proudly declares the dissolution of the Menominee reservation. The decision was seen as freeing the tribe from being a ward of the state, which sounds like a positive step; however, the removal of federal protections plunged the county into turmoil. (Courtesy Shawano Public Library.)

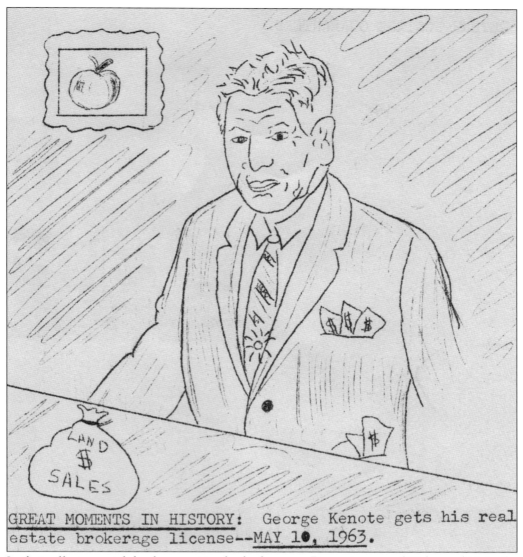

GREAT MOMENTS IN HISTORY: George Kenote gets his real estate brokerage license--MAY 10, 1963.

In their efforts to get federal recognition back, the group Determination of Rights and Unity for Menominee Stockholders (DRUMS) released various newsletters. This political cartoon from the newsletter is a scathing attack on George Kenote, chairman of Menominee Enterprises. DRUMS accused Kenote of treating the tribe like "little children."

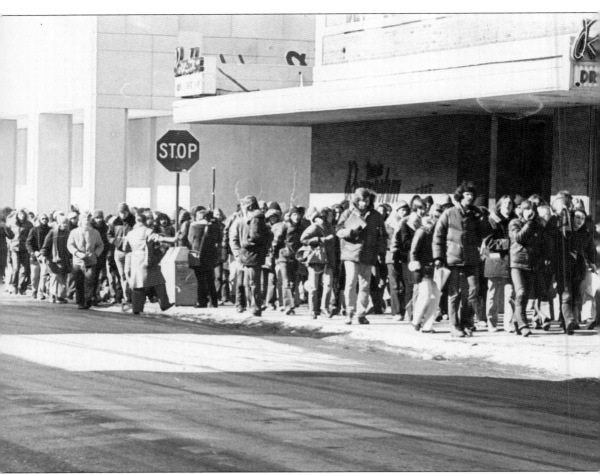

Protests began over the killings of two Menominee tribal members on February 2, 1976, by Menominee County sheriff Kenneth Fish, after officers responded to a domestic complaint at the home of one of the men. Demonstrations included a march to the state capital. (Courtesy Wisconsin Historical Society.)

Glen Miller (1951–1995) was seen as a future leader in the 1970s, and he proved his contemporaries right. He became tribal chairman and pushed ahead on both tribal gaming and the tribal college before his untimely death at age 44. (Courtesy National Geographic Society.)

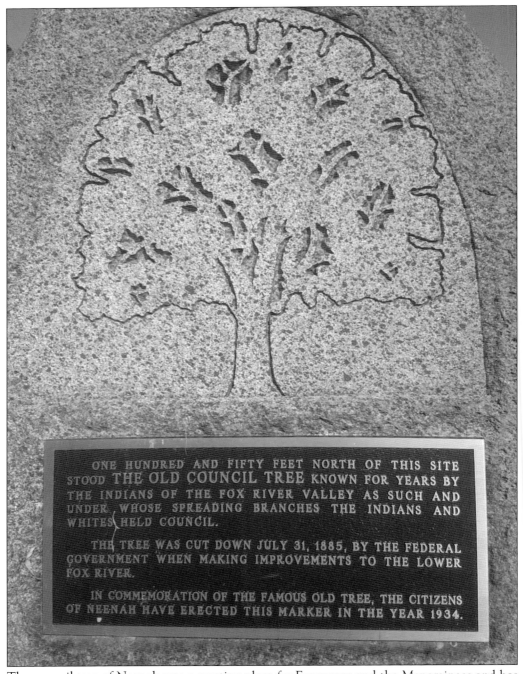

ONE HUNDRED AND FIFTY FEET NORTH OF THIS SITE STOOD THE OLD COUNCIL TREE KNOWN FOR YEARS BY THE INDIANS OF THE FOX RIVER VALLEY AS SUCH AND UNDER WHOSE SPREADING BRANCHES THE INDIANS AND WHITES HELD COUNCIL.

THE TREE WAS CUT DOWN JULY 31, 1885, BY THE FEDERAL GOVERNMENT WHEN MAKING IMPROVEMENTS TO THE LOWER FOX RIVER.

IN COMMEMORATION OF THE FAMOUS OLD TREE, THE CITIZENS OF NEENAH HAVE ERECTED THIS MARKER IN THE YEAR 1934.

The council tree of Neenah was a meeting place for Europeans and the Menominees and has since become part of the Neenah seal. Neenah, originally called Winnebago Rapids, was set up by the government as an educational center for the tribe.

BIBLIOGRAPHY

Ayer, Edward E. *Report on Menominee Indian Reservation.* London: Forgotten Books, 2015.

Beck, David R.M. *Siege and Survival: History of the Menominee Indians, 1634–1856.* Lincoln: University of Nebraska Press, 2002.

———. *The Struggle for Self-Determination: History of the Menominee Indians since 1854.* Lincoln: University of Nebraska Press, 2007.

Hosmer, Brian C. *American Indians in the Marketplace: Persistence and Innovation Among the Menominees and Metlakatlans, 1870–1920.* Lawrence: University Press of Kansas, 1999.

Peroff, Nicholas C. *Menominee Drums: Tribal Termination and Restoration, 1954–1974.* Norman: University of Oklahoma Press, 2006.

Spindler, George. *Dreamers with Power: The Menominee.* Long Grove, IL: Waveland Press, 1984.

DISCOVER THOUSANDS OF LOCAL HISTORY BOOKS FEATURING MILLIONS OF VINTAGE IMAGES

Arcadia Publishing, the leading local history publisher in the United States, is committed to making history accessible and meaningful through publishing books that celebrate and preserve the heritage of America's people and places.

Find more books like this at
www.arcadiapublishing.com

Search for your hometown history, your old stomping grounds, and even your favorite sports team.

Consistent with our mission to preserve history on a local level, this book was printed in South Carolina on American-made paper and manufactured entirely in the United States. Products carrying the accredited Forest Stewardship Council (FSC) label are printed on 100 percent FSC-certified paper.

MADE IN THE USA